C000002655

ONCE UPON A TIME IN WALES

ONCE UPON A TIME IN WALES
by Robert Haines

First published in the
United Kingdom in 2008 by
Dewi Lewis Publishing
8 Broomfield Road
Heaton Moor
Stockport SK4 4ND
England

www.dewilewispublishing.com

©2008
for the photographs and texts: Robert Haines
for this edition: Dewi Lewis Publishing

ISBN: 978-1-904587-57-6

Design and Layout: Dewi Lewis Publishing
Print: EBS, Verona, Italy

with the support of

ONCE UPON A TIME IN WALES ROBERT HAINES

DEWI LEWIS PUBLISHING

MERTHYR PORTRAITS
ROBERT HAINES

This collection of photographs was taken around 1971-2 when I was twenty years of age. They record some of the characters from the village of Heolgerrig and the nearby town of Merthyr Tydfil.

I was born in Penyrheol House. Known as the 'Big House', it was a mansion built in 1881 by Christmas Evans on the site of an earlier timber framed house. A wealthy mine owner from the Rhondda, Evans was owner of the Six Bells colliery, which was the colliery where Richard Llewellyn based his novel *How Green Was My Valley*. Over the years, amongst the visitors welcomed to the house, there were many poets and radical thinkers. The poet and opium addict Iolo Morganwg, creator of the Gorsedd bards, was a frequent visitor. It was here that the very first ballot box was proposed and constructed; it was here that Morgan Williams, the Chartist leader, was born and the red flag was raised for the first time in this country. The house had beautiful landscaped gardens and was the largest house in the village of Heolgerrig, a small hamlet of several hundred houses on the outskirts of Merthyr Tydfil, in South Wales, once the 'Iron Capital' of the world.

Christmas Evans' father Evan Evans was born penniless. He worked hard and eventually saved enough to buy the Old Six Bells pub in Heolgerrig. He was a shrewd businessman and said, "On pay day the men will be paid at the pub and, knowing their calibre, I can wager that most of the wages will be handed back over the counter." He made a lot of money, constructing a massive brewery alongside as well as opening hugely successful collieries in the Rhondda and Ogmore valleys. His son Christmas inherited the business, bought Penyrheol House and lavished vast amounts of money on it. It had huge stables and a magnificent conservatory.

Remarkably, in the middle of the last century my grandfather, Job, followed in the footsteps of Evan Evans.

Mam and Dad, Eirwen and Eurfil. My father had just returned, a little merry, from the Club and wanted me to photograph him with my mother.

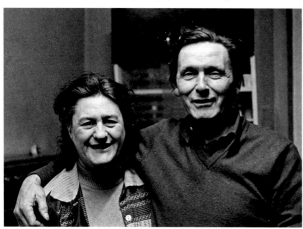

Job started work as a collier at the age of twelve and over time managed to save enough to buy the Six Bells pub. Later he also opened a number of small mines until eventually he was contracted to supply coal to all the South Wales power stations. He bought Penyrheol House and moved in with my parents, and it was there that I was born.

When I was eleven, my father's business failed. We moved out of Penyrheol House and its beautiful mature gardens were flattened to make a car park. The house itself was converted into the Heolgerrig Social Club.

The Haines family was well established in the village, and it seemed as if most people were related to me in one way or another. I was taught in school by Mr Simon Haines and my head teacher was a Mrs Sophia Haines. The family tree can be traced back to Job Haines, a drover from Cirencester who settled in the village in the mid-nineteenth century.

Heolgerrig was a very close-knit community. Welsh was the first language. It was a mining community, and most of the men worked underground. Life then seemed to revolve around the pub and the chapel. Yet it was a very cultured place; art was encouraged and admired above all. I remember a great-aunt telling me that her son was going to waste his life because he had become a successful barrister – if only he'd become a musician or an artist, she said. The colliers believed highly in education, which resulted in a mass exodus from the area by their educated sons and daughters in the search for decent jobs.

The early Seventies were a time of flux. It felt at the time that everything was changing. The village was built along the main road, and was surrounded by pasture land. It had a wonderfully rural feel, yet it was less than a mile from the industrial town centre of Merthyr Tydfil. It wasn't long before this ideal location gave rise to the building of huge housing estates that sprang up along the entire length of the main road. It was becoming a desirable area to live. Heolgerrig would never be the same again.

In Georgetown and Dowlais, areas which were then warrens of small ironworkers' cottages, there were major redevelopment plans. I wanted to record some of the characters, especially those who seemed to have drifted in from a previous century. We would never see the likes of them again. The majority of those that I photographed were not wealthy or famous but the unknown, the poor with no voice. They spent their days drinking cider, working underground, and living in often terrible conditions. I also photographed S.O. Davies, our long-standing MP, who over many years had been a champion of the working class.

Some of the people I knew well, some were family members, others complete strangers. I spent time with some of them, often having a pint in Ye Olde Express, The Lamb Inn or The Red Lion. Others were just fleeting images, strangers I passed in the street.

Merthyr was a tough town and justifiably so. Some of the characters in my photographs were hard men. Yet a common factor was that they all enjoyed having their photographs taken. It made them feel important.

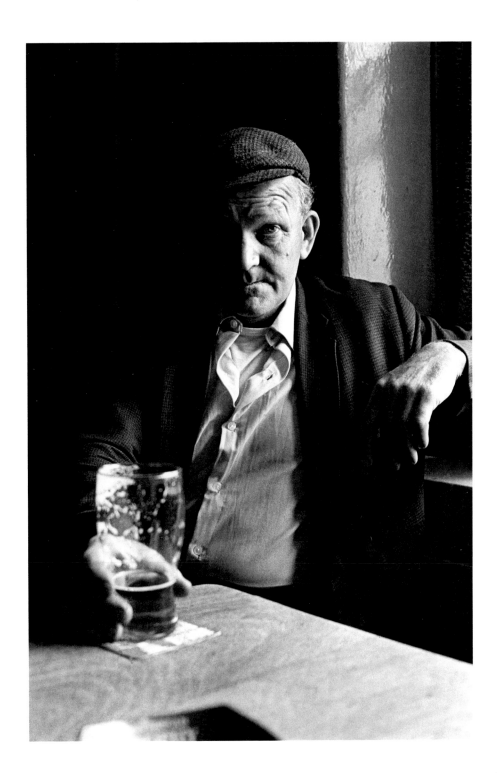

Raymond Owen was a typical Welsh collier. For most of his life he worked nights. In the afternoon he would have a few pints in the Red Lion, before returning home for a meal then a few hours sleep. By 10pm he would be working underground at the coalface. His father was a farmer and, like many of the old colliers, Raymond loved the countryside. Spending so much time in the hostile conditions of the mines they appreciated sunshine and clean air.

Trevor Protheroe, John the Lamb and Jim Ryan.

The family of Johnny Lewis, landlord of the Lamb, was from Heolgerrig. Before the Second World War, Johnny trained as a jockey in Worcestershire. His other ambititon was to be a vet. His brother became an Anglo-Catholic priest in Spain. The Lamb was an extraordinary pub. Here you would meet people from every walk of life: barristers to the unemployed. Harry Webb the poet used to drink there, as did Jack the Roller, Sid Hill and the Brigadier along with Swazi the Indian chef who once pissed on his potatoes. In 1973 the pub was demolished by the council to redevelop the town centre.

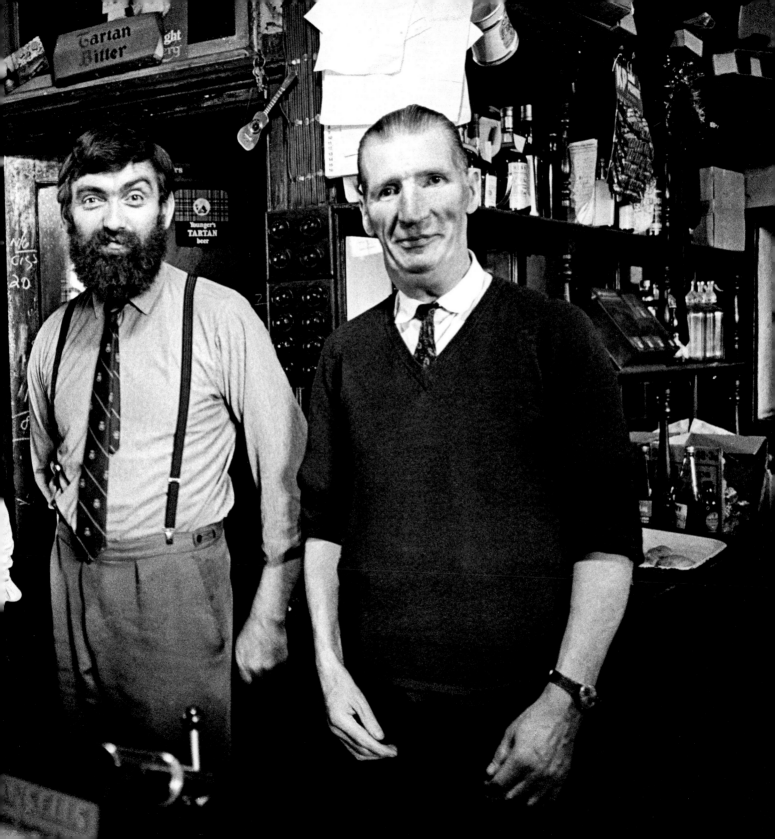

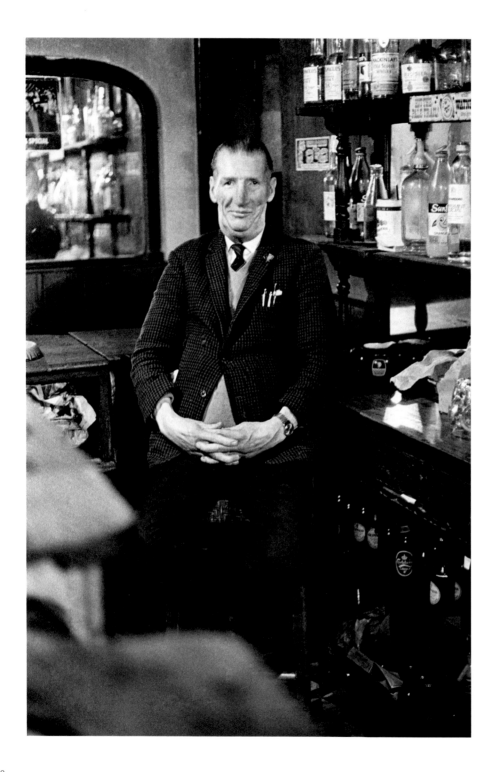

Jim Ryan, barman at the Lamb. The landlord, John, used to say that Jim was a brandy specialist, and that he capitalised on the brandy situation. 'Have a go on the Martell and leave the Hennessy for a month,' he would yell at him, usually to no avail. In his spare time Jim used to lay out the dead for a local undertaker.

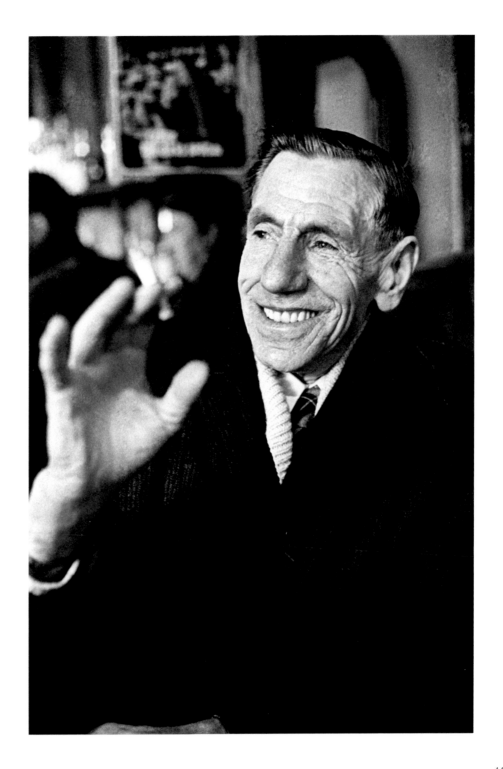

Man in The Lamb Inn.

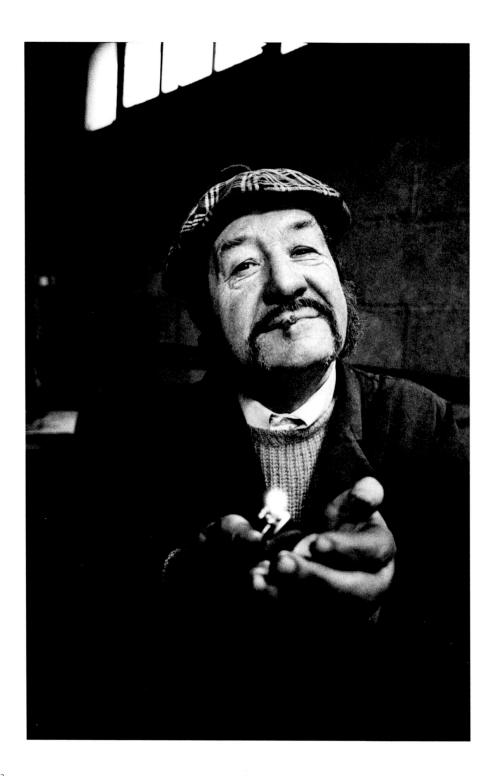

The Engineer at a Merthyr
engineering company, where I
worked for a short time as a student.

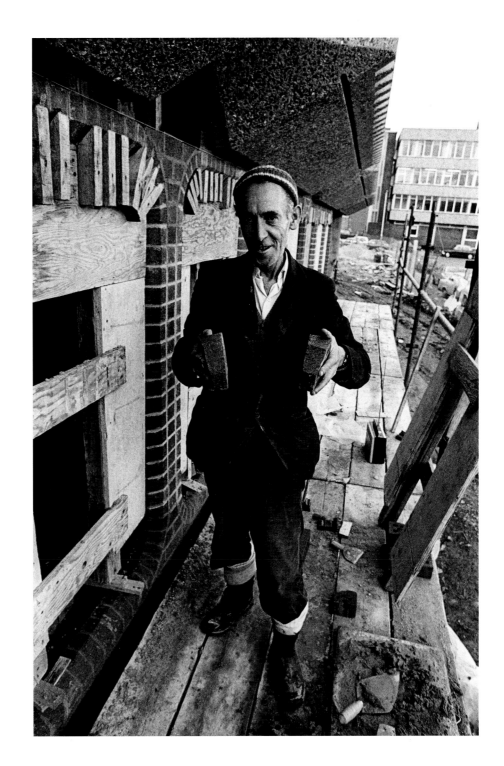

Billy Bricks 'Delilah'. After a few pints Billy would shuffle up and down the bar singing Tom Jones' *Delilah*. His leg movements were not unlike Michael Jacksons' moonwalking – he was years before his time. Billy was a very skilled bricklayer. When a new court building was being constructed in the town there was only one man who could do the brickwork. However, the contractors had to employ a man just to ensure that Billy didn't sneak off to the pub before the end of shift. He can be seen here working on one of the windows.

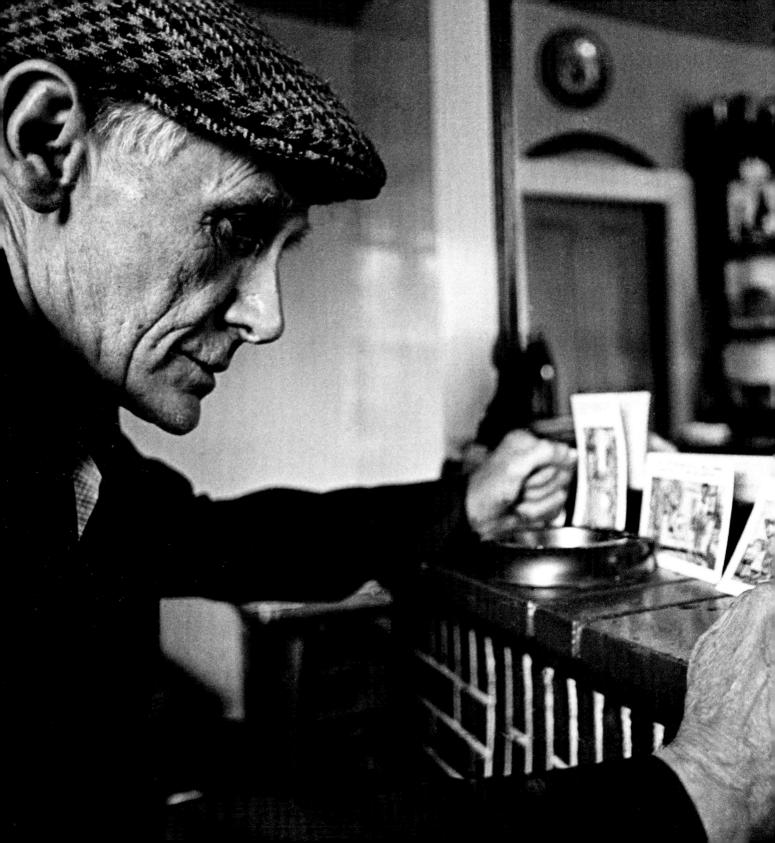

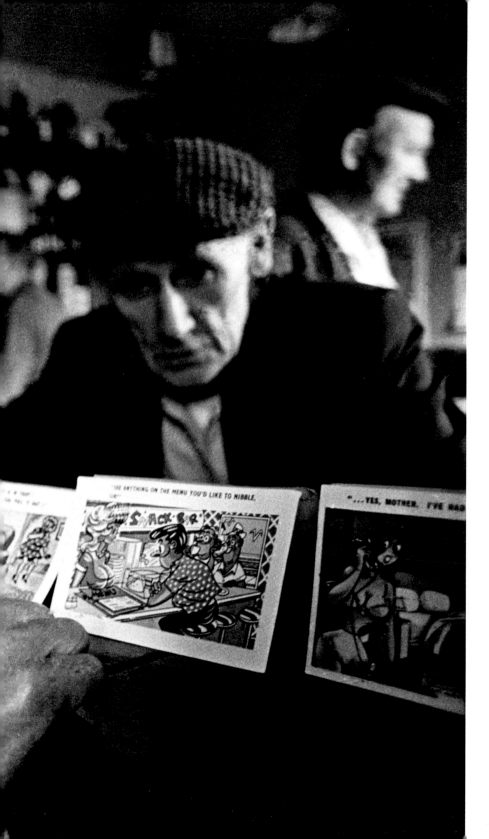

Tudor Peters, in the small bar of the Red Lion, looking at holiday postcards. Each summer when the pub regulars took their fortnight summer holiday they would send postcards back to the pub where they were placed by the landlord on the mantelpiece. Tudor, like many of the colliers, was no great traveller. He worked in the Town Hall. His family had cows and supplied milk which they delivered by horse and cart.

Melvin Webber, Merthyr hard man. Not to be messed with. Lived hard and died hard after being blasted with a shotgun.

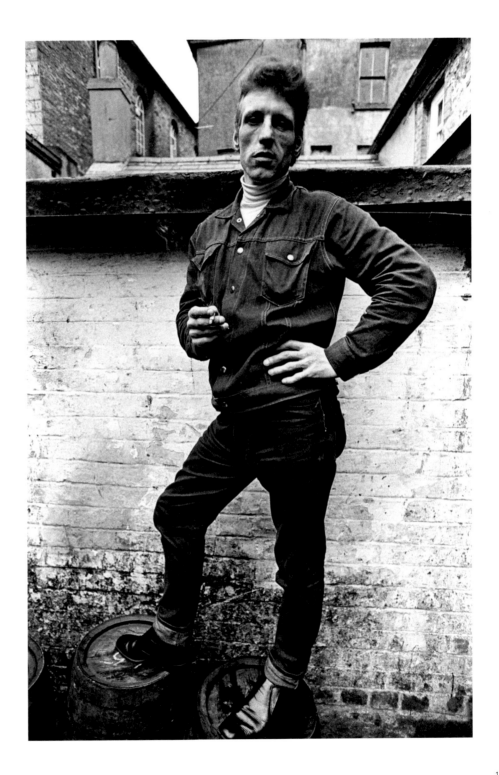

Billy Diana. Billy loved to woo the women with his sexy rendition of the Paul Anka song *Diana* – his signature tune. After a few pints you couldn't stop him. He would gyrate his hips wildly in an Elvis Presley style.

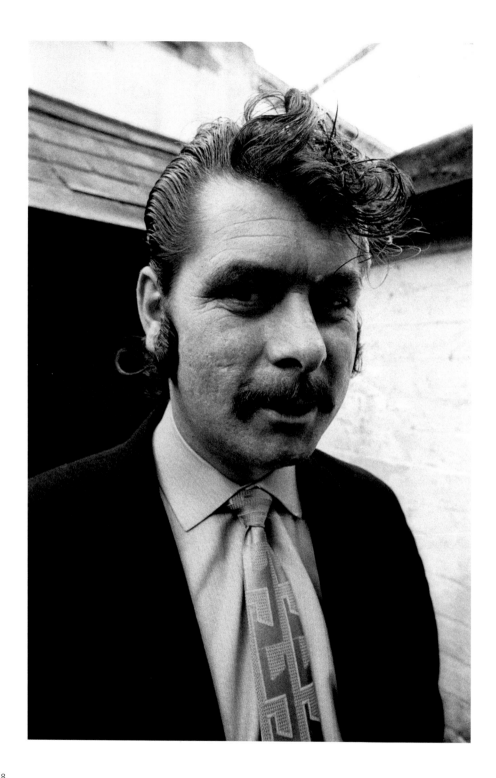

Roy Evans. A hard character about town. He treated me with great respect and humility.

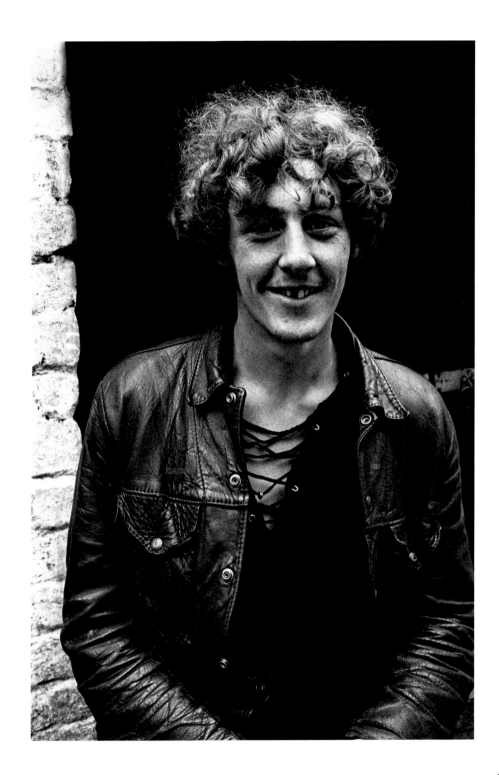

Mad Malcolm. No chemical substance was too hot for Malcolm. He had just taken some speed with his cider before I photographed him. He died after hitting a lamppost at high speed on a motorbike while fleeing the police. A lovely friendly type.

Cochin, Eddie Abrahams, Job Haines and Rees Jones. Rees is smoking an old clay pipe. The photograph was taken in the lounge of the Heolgerrig Club. Up until 1963 the building was a beautiful landscaped mansion known as Penyrheol House or The Big House. It was where I lived for the first eleven years of my life. This room used to be our lounge. In the centre background is my father, standing near the door is a member of the committee.

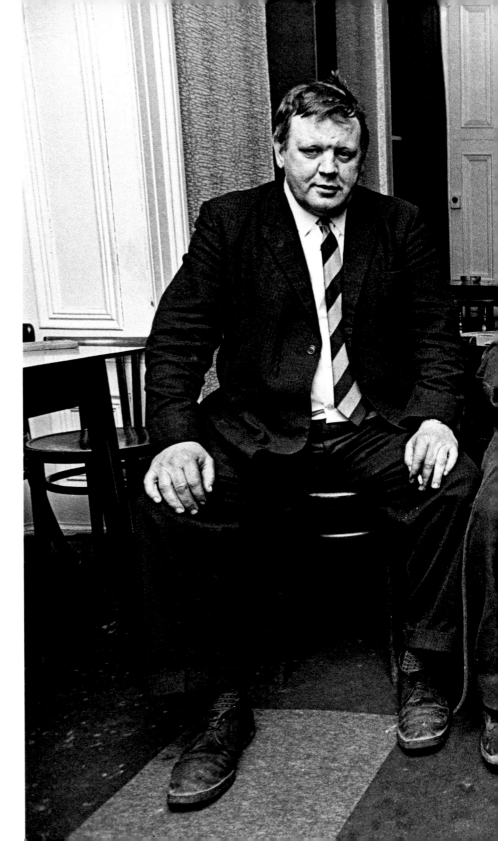

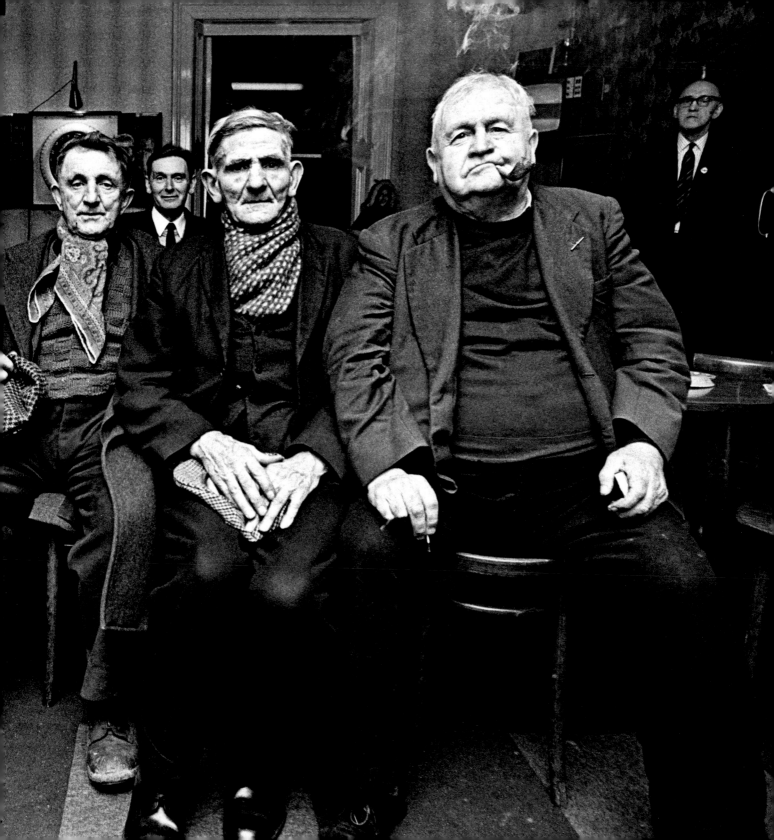

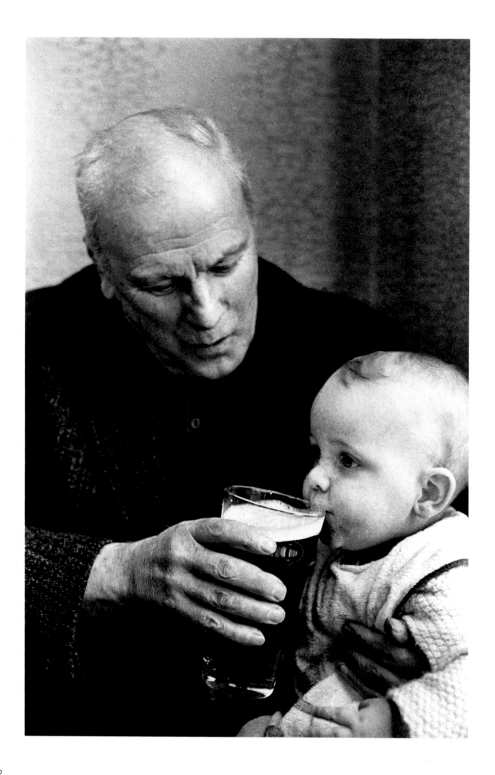

Under-age drinking. Dai Edwards is giving a young child a first taste of beer in the Heolgerrig Social Club. Dai lived at the top of Heolgerrig with Maggie Soap, so named for her habit of rubbing soap into her hair to give it body. Dai once hid his life savings beneath the floorboards of a caravan. Some months later he discovered it had all disappeared – eaten by mice.

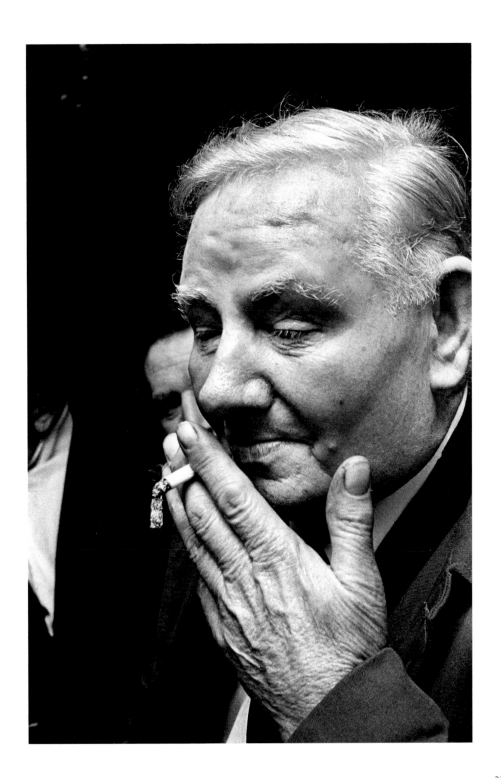

Dick the Rock was a stone-mason and wrote Welsh poetry. He was steadfast and showed great strength of character. He never swore, but would often recite and sing his works in The Lamb. He was found dead at his home covered in sacks.

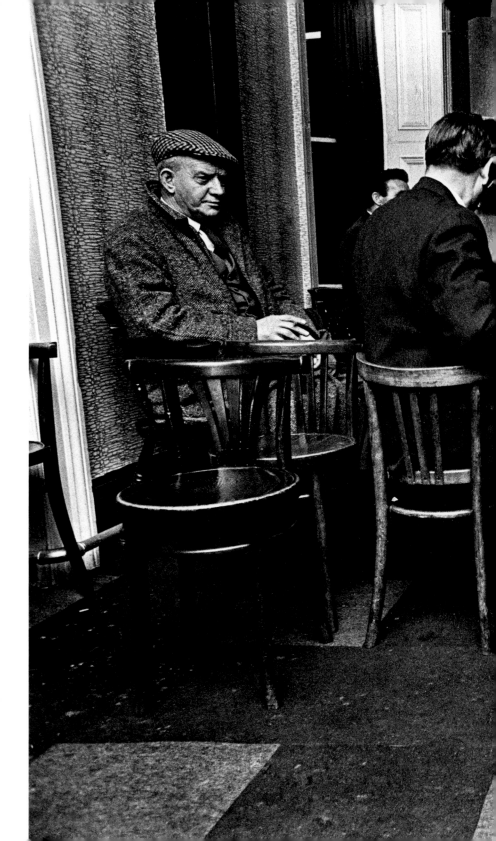

Bryn Dan with his walking stick –
the Errol Flynn of Heolgerrig. It was
Saturday night at the Heolgerrig
Social Club and Bryn was dressed to
impress the ladies. The evening would
be spent in the Lounge Bar. He was
a carver of walking sticks and always
carried an example with him to
demonstrate his skills.

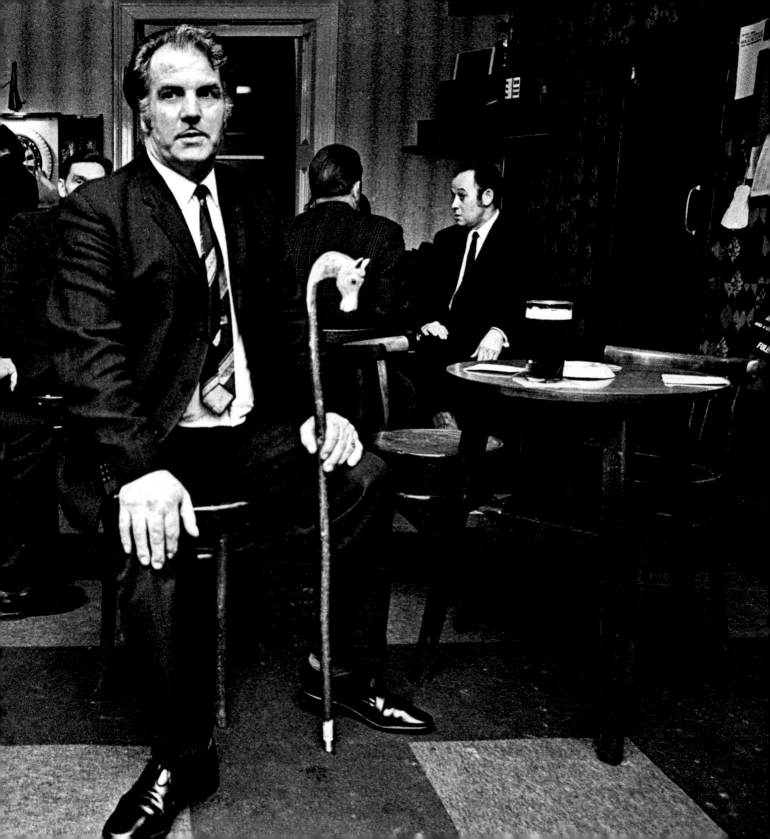

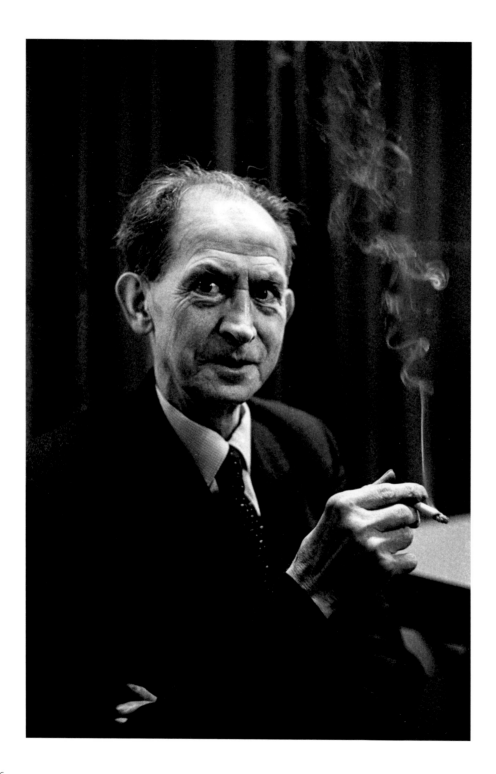

Bryn Llewellyn was a collier, a quiet man who loved gardening.

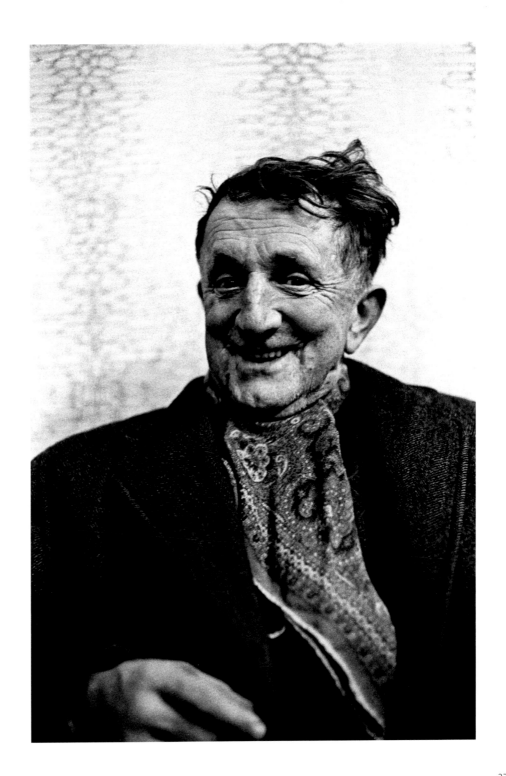

Eddie Abrahams after a few pints. Eddie was a short stocky man. He didn't go out often but when he did he would get blind drunk. He would invariably end up on the floor, lying on his side, demonstrating his technique for cutting coal in a two-foot seam. When drunk he would curse and swear aloud. This often resulted in him being ejected from pubs. Swearing was not allowed in any of the town's pubs. "I'm not a Teddy Boy, I'm a tidy boy," he would say as a form of apology.

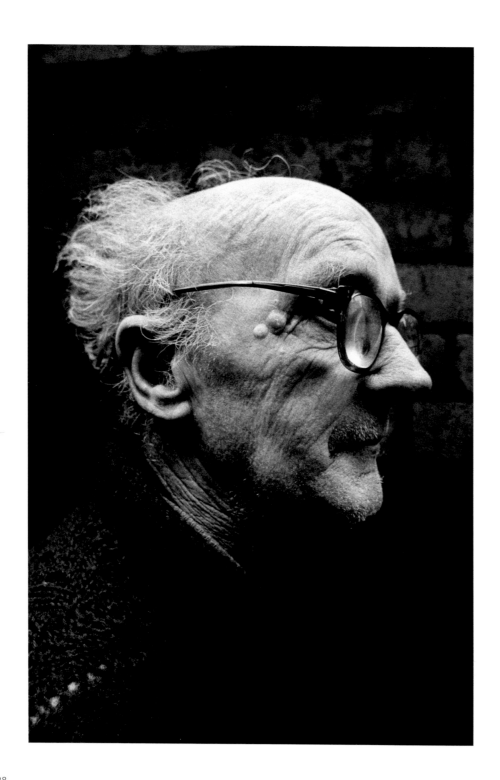

Bill Baldy was nearly seventy. He drank rough cider in Ye Olde Express pub and rolled his own from the nips of used cigarettes which he recycled from the ash-trays and stored in a little tin box – Mintoes he called them. He would quote the Iranian poet Omar Khayyam "Let us be happy, Time is passing by. There is no return, when you go you are gone." And he would drink every day until he was legless. He would drink anything and claimed that he had once drunk Brasso. "I've never fucking worked and I never fucking will," was his motto.

Eunice Lewis, Bill Baldy's girlfriend. "She has lovely titties," Bill always said of her.

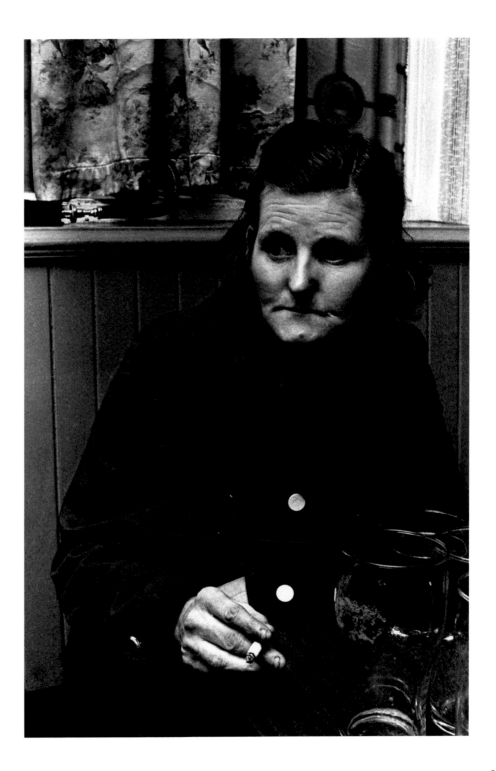

Bill Baldy, with all his worldly possessions. This was the room which he shared with five others in the "bloody doss house", as he described the Castle Hotel lodging house.

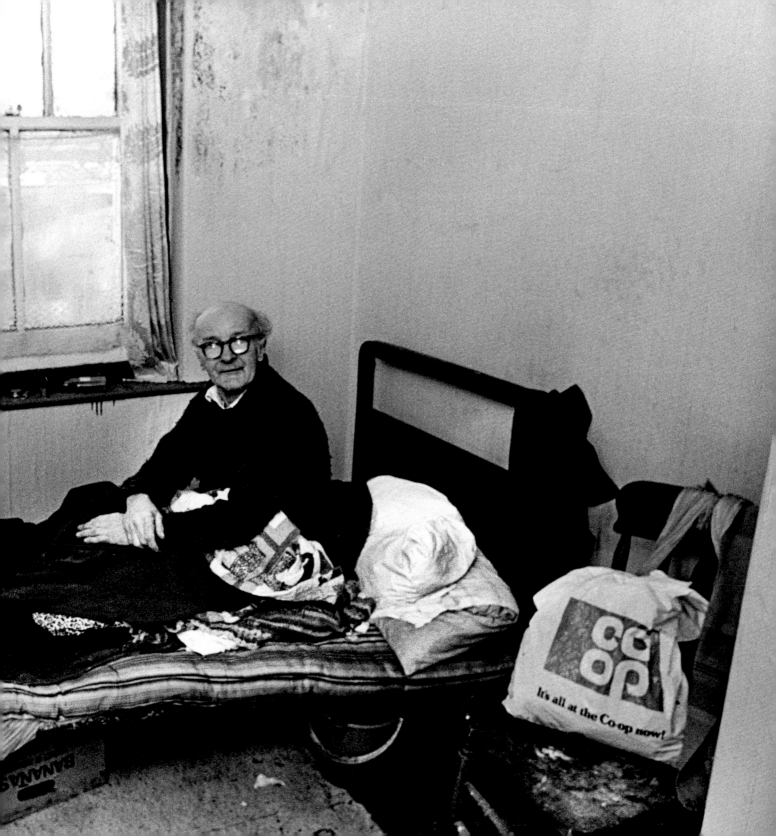

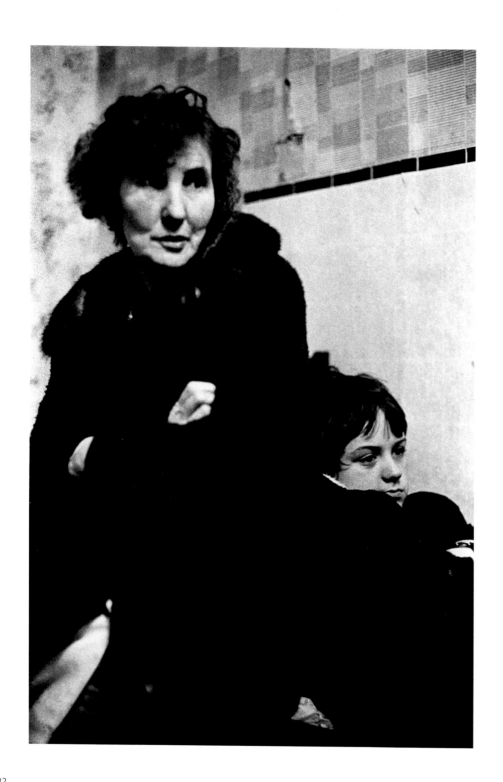

Auntie Rhoda watching television with my brother Martin. Auntie Rhoda was an angel – the most perfect person I have ever met. She devoted her life to others and thought nothing of herself. She adored children. She looked after my father when he was a child, she looked after me and my brother and in later years she looked after my son. She never had any children of her own. When she was in her eighties she used to do the shopping for the old people in the village.

Auntie Rhoda with my brother Martin. She doted on him. Here she had cooked him a TV dinner.

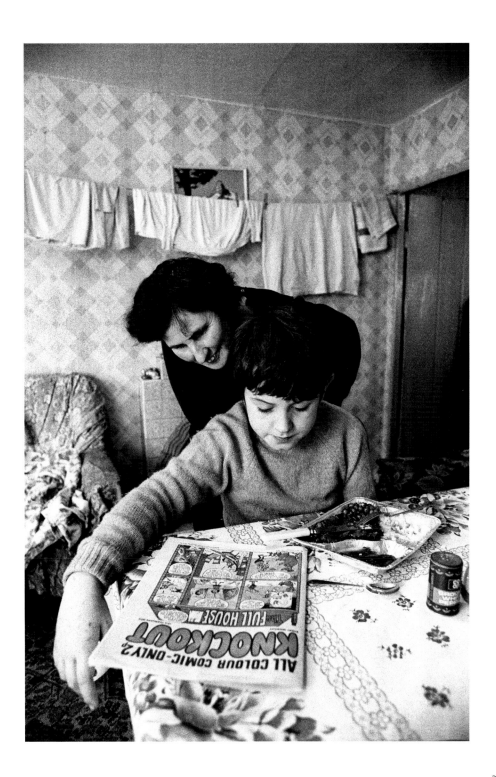

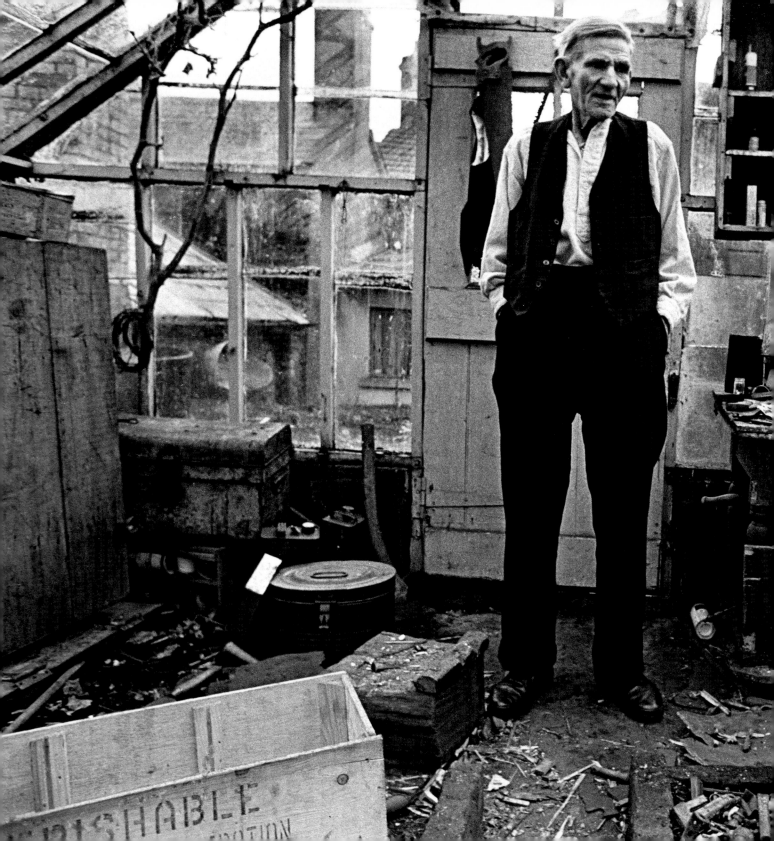

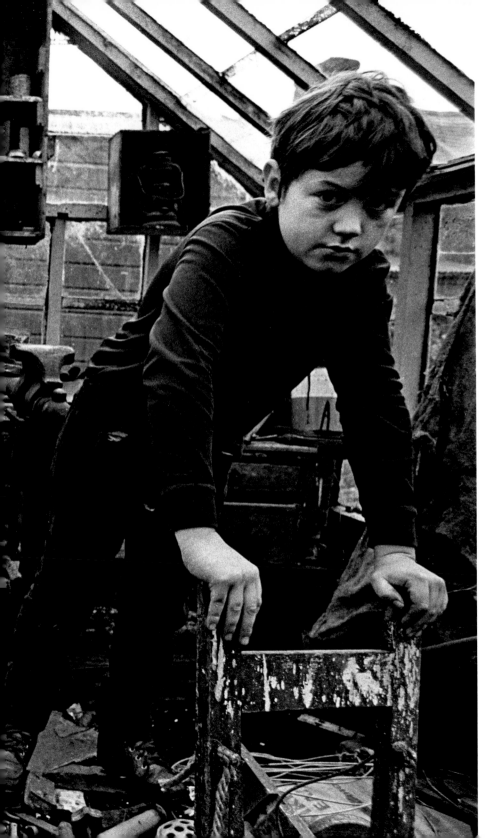

My grandfather Job in his green-house with my brother Martin.

My grandfather was an incredible man. As a young child he used to go to the grounds of Penyrheol House on Christmas morning. Christmas Evans, a wealthy mine owner would toss coins into the air for the local children. Starting work underground at the age twelve my grandfather worked hard. Eventually he bought the Six Bells pub and later opened two small private mines, becoming the main supplier of coal to the South Wales power stations, and a major employer. In the 1950s he bought Penyrheol House, but in the late 1960s the business went bankrupt and he moved into a small miner's cottage. One thing he took with him from the mansion was a huge greenhouse where he grew grapes. My nine-year-old brother would play there.

Job was a national quoits champion and a great singer of old Welsh folk songs which had countless verses and went on and on. When he died over 20 songs were lost forever. Like many old colliers he had silicosis and the last few years of his life were spent connected to an oxygen cylinder.

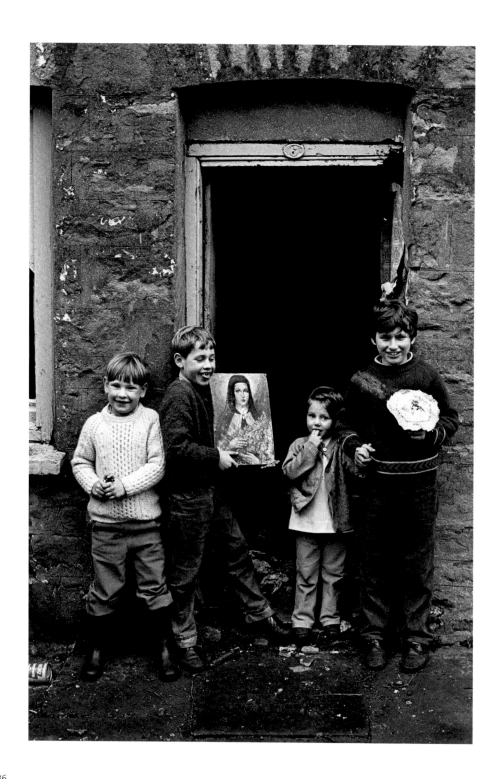

Children playing in a derelict house in Georgetown, Merthyr. They had found a painting inside the building and asked me to photograph them with it. The redevelopment of Georgetown had already started and houses were being cleared.

Members of Old Mister Jones and Old Mrs Jones' gypsy family outside their first home in Georgetown.

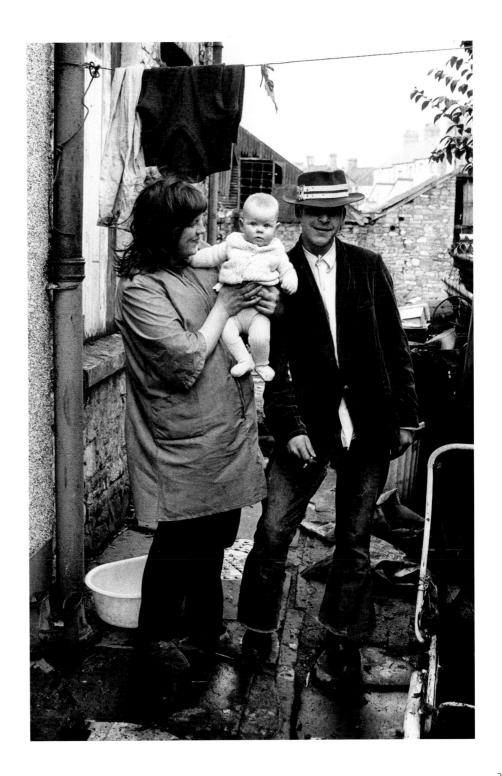

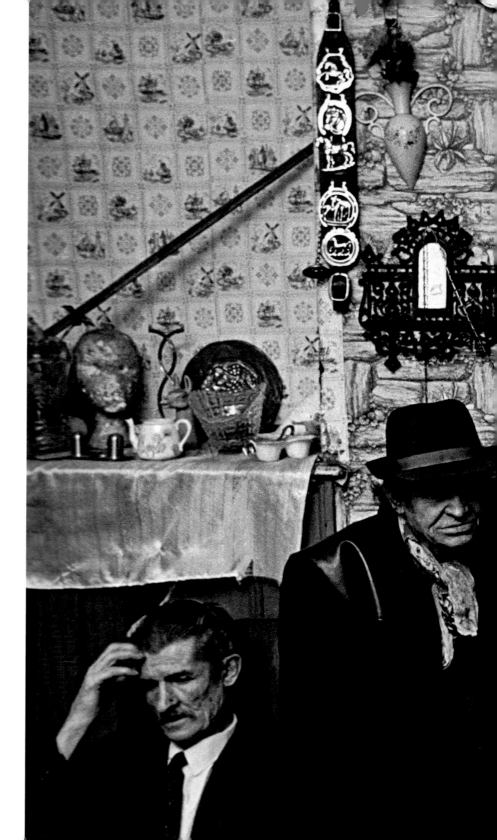

Old Mister Jones and Old Mrs Jones with their family. Old Mister Jones is sitting on the far left and Old Mrs Jones is holding the baby. The family were originally Romany gypsies who sold their caravan and settled in a house off Bethesda Street. I don't know how they acquired the Jones name.

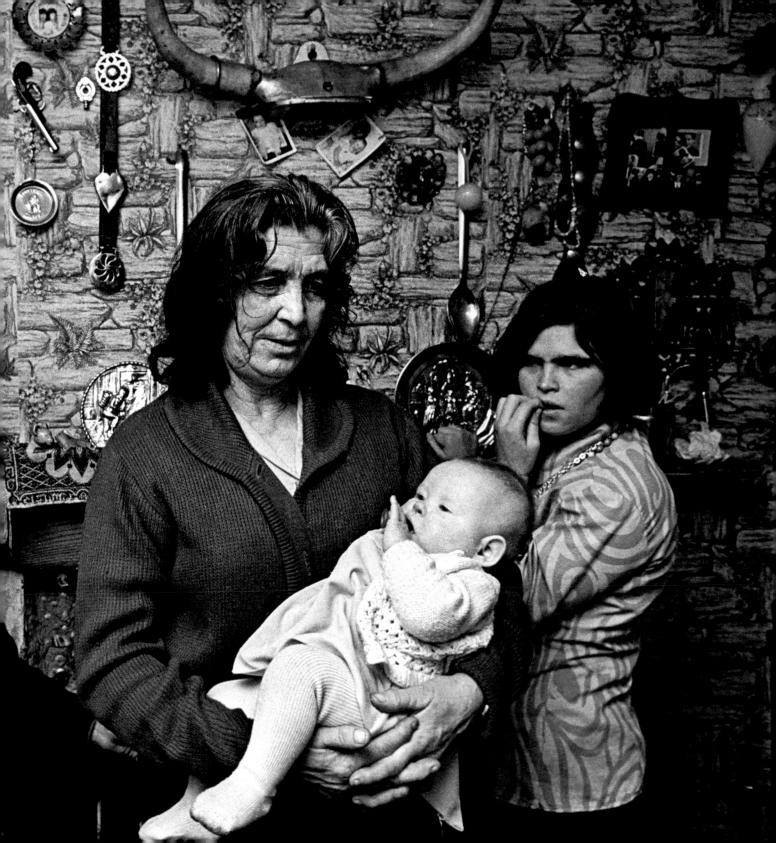

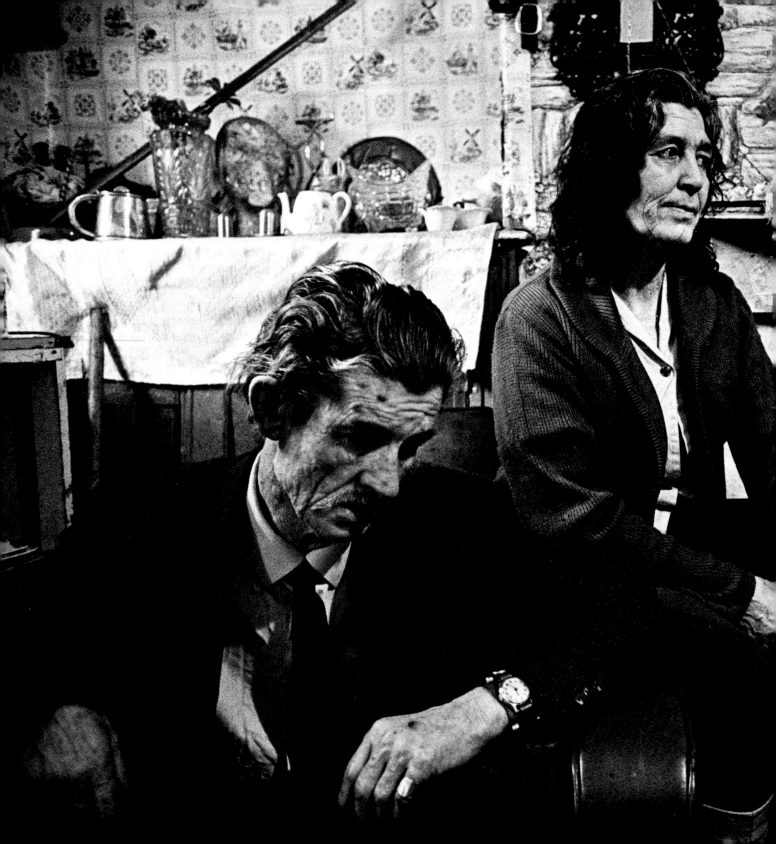

Old Mister Jones and Old Mrs Jones.
Old Mrs Jones used to sell pegs
around the streets.

Girl in a miniskirt with her dog, Georgetown. These were ironworkers' cottages built in the 19th century.

Woman, Georgetown.

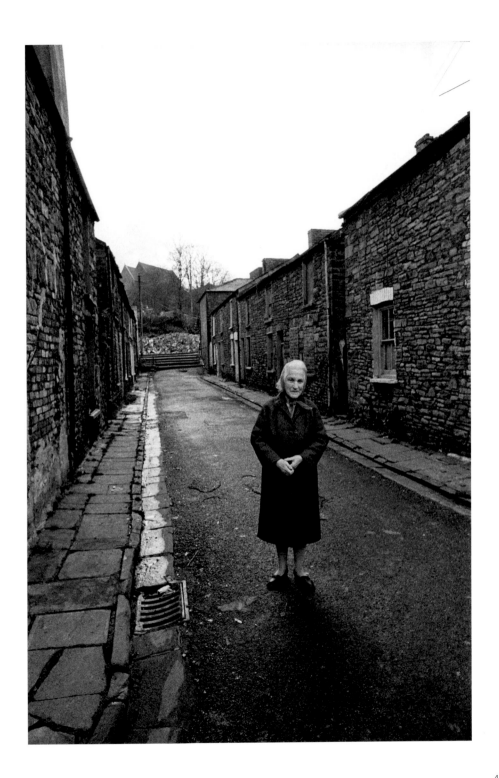

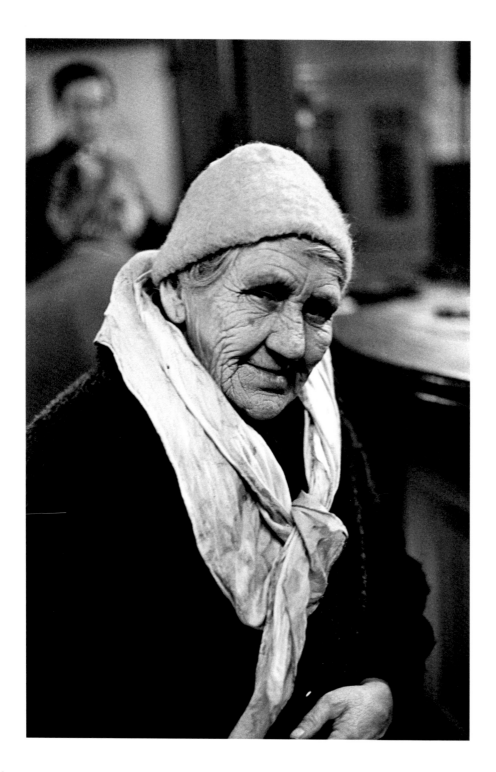

Another Old Mrs Jones, in the Express pub where she was drinking stout. She had four sons, one of whom I remember was known as Decimal Dai.

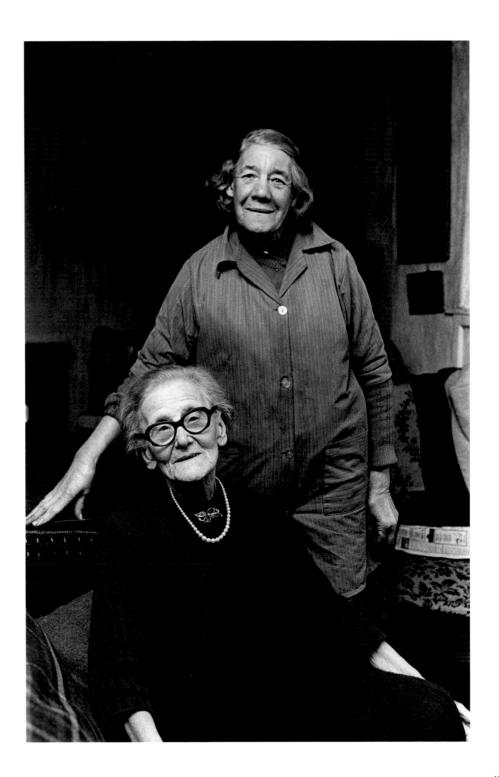

Two charming ladies from Heolgerrig who invited me into their home to take their portrait.

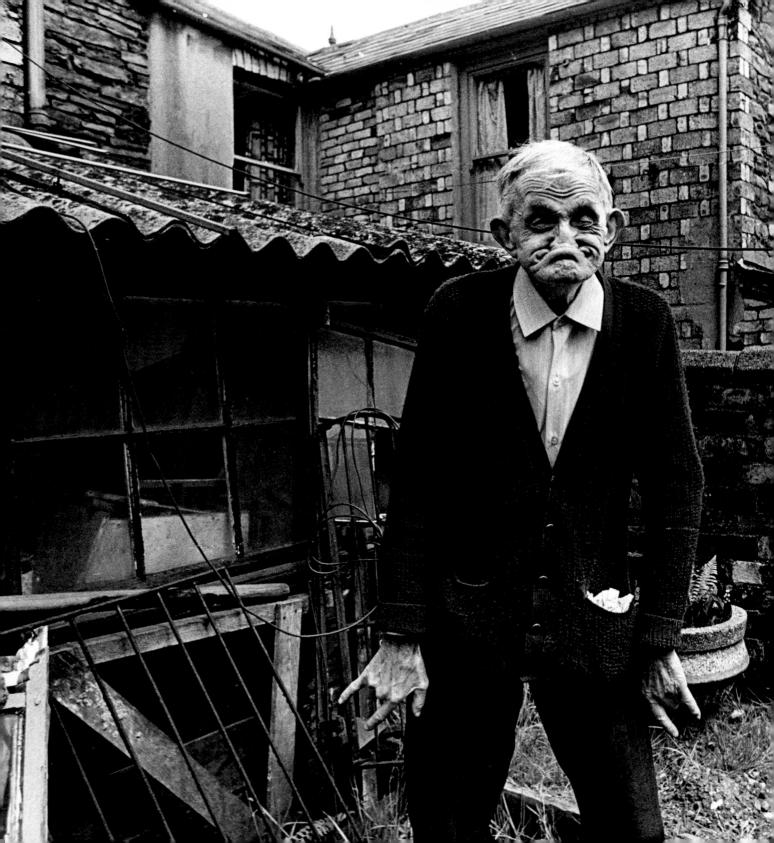

Dai Llewellyn. Not quite the World's best gurner but he did come 3rd in the 1968 World Gurning Championships. It always seemed that the Welsh colliers were very adept at pulling funny faces.

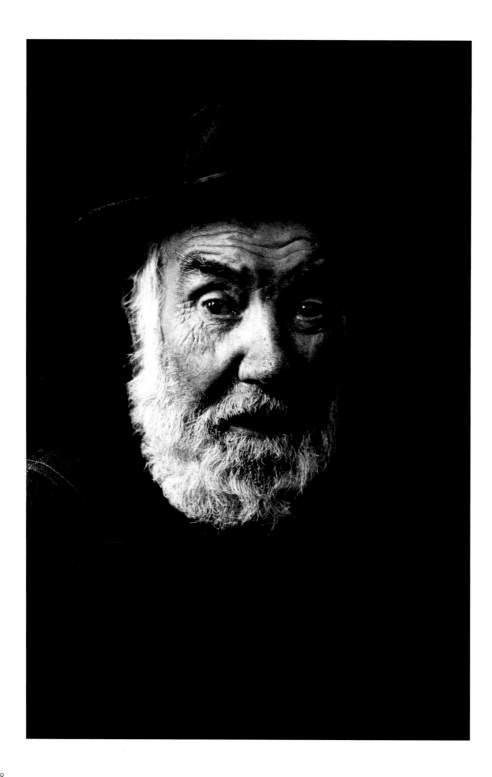

Old man Jenkins in Ye Olde Express pub.

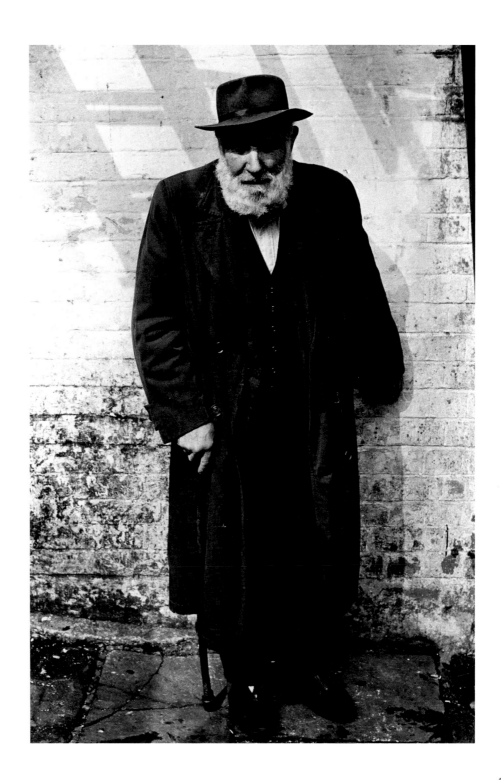

Old man Jenkins at the back of Ye
Olde Express pub. He lived next to
Barnes' Fishing and Shooting shop in
Castle Street. He had very bad legs
and would often be seen shuffling
around in his slippers.

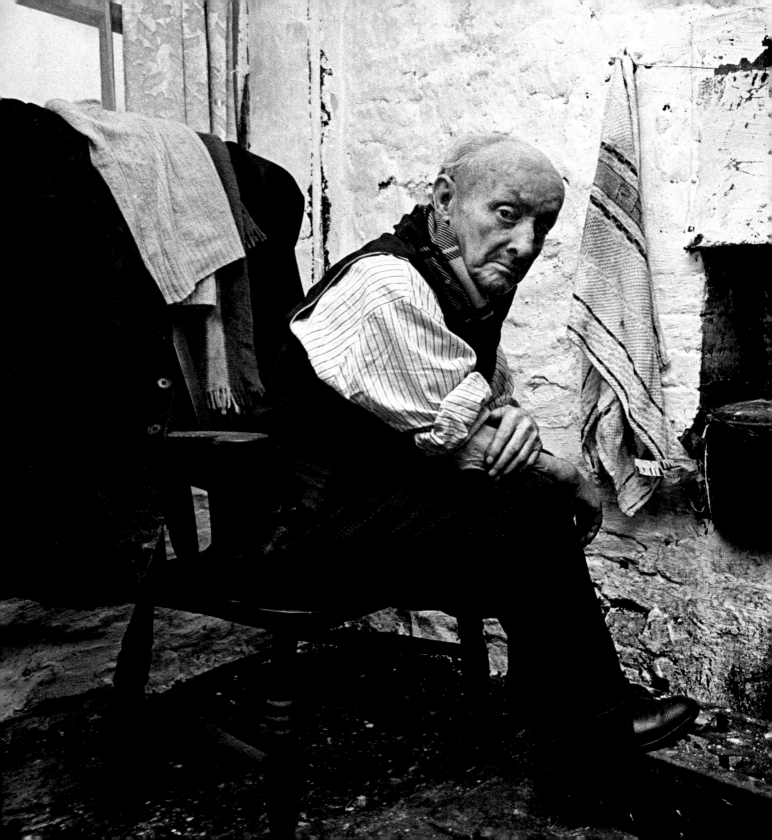

Old Phil was ninety-three and lived in a lodging house known as the Castle Hotel. Here he is sitting next to the fireplace in the kitchen. He looked after himself very well and always had a shine on his shoes.

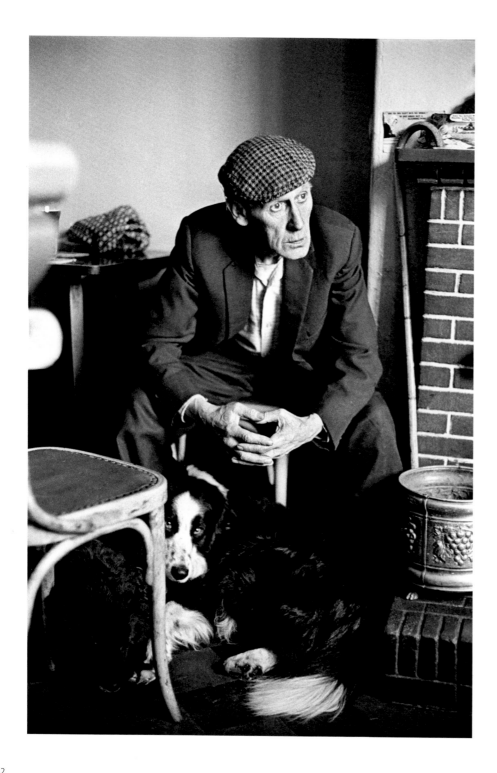

Tudor Peters and his dogs in the small, old bar of the Red Lion. The pub would hold around a dozen with a tight squeeze. Tudor had a bit of a smallholding and loved farming.

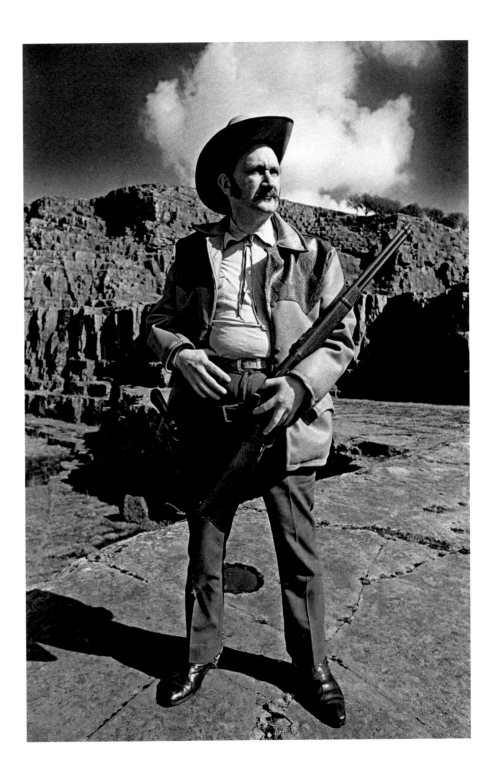

Tex Jones. Tex was the father of my schoolfriend Wayne. He lived on the Gurnos Estate and was crazy about the Wild West. He was also a very skilled leather worker and made belts, wallets and all sorts of things. He had a stool which he had made out of a Western Saddle and he would perch on it whilst eating baked beans out of a tin and watching Westerns on television. I photographed him at Morlais Castle quarry not far from his home.

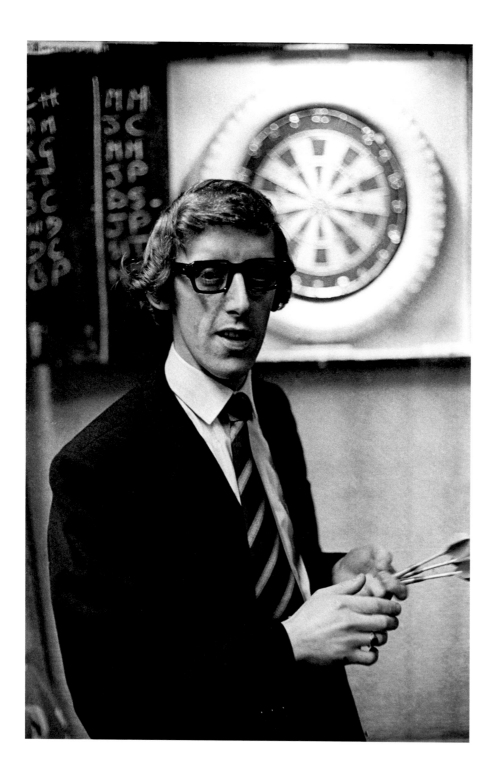

Clive the darts. Clive Thomas was a civil servant who had a great way with numbers. He was forever throwing darts to raise money for one good cause or another. In later years he took to drink and died young.

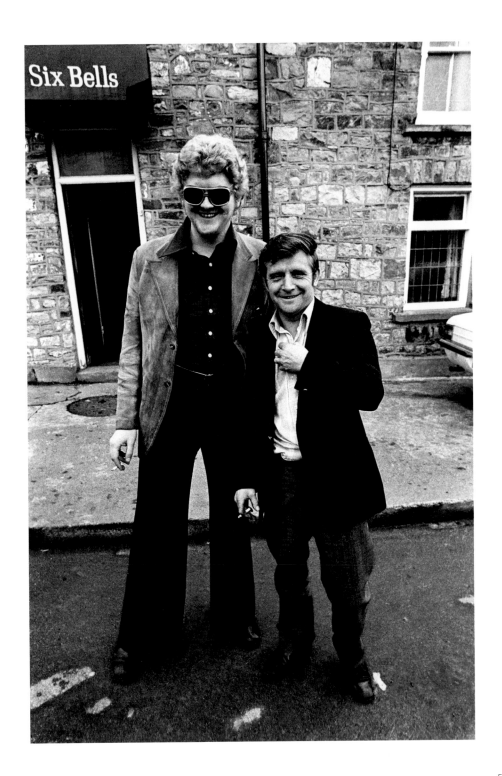

Arwel Reed and Mel Jones emerge after a good afternoon session in The Six Bells. Arwel was a young police officer. He used to go fishing with Mel who was a very keen fisherman.

Uncle Les asleep in the sun. Les was my Auntie Rhoda's husband. On Sundays in the summer they would often take me out in the car for a picnic. Les liked to drive to the nearby Brecon Beacons. There we would have sweet tea, ham sandwiches and cream cakes laid out on a cloth. Afterwards Les would invariably fall asleep in the sun. Rhoda would worry about him being burnt and would attempt to cover him with the cloth. It was probably a miracle she never suffocated him.

I always remember an occasion at their home when she woke him up because he hadn't taken his sleeping tablet.

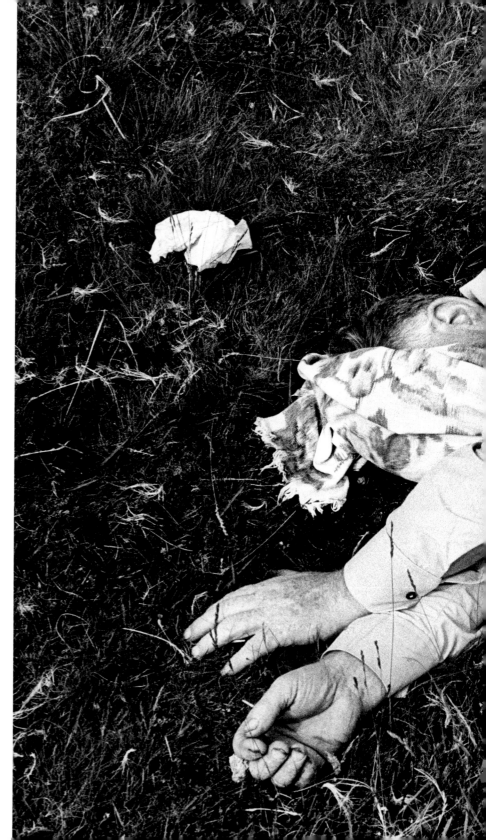

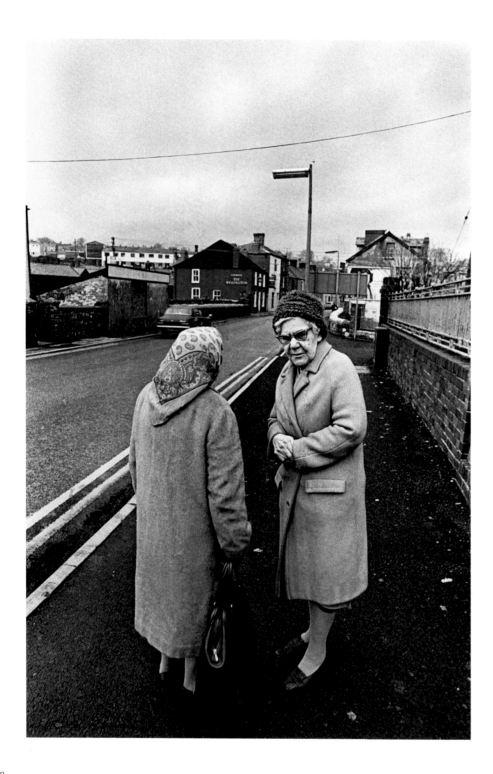

Two women gossiping in Bethesda Street near Jackson's Bridge, Georgetown.

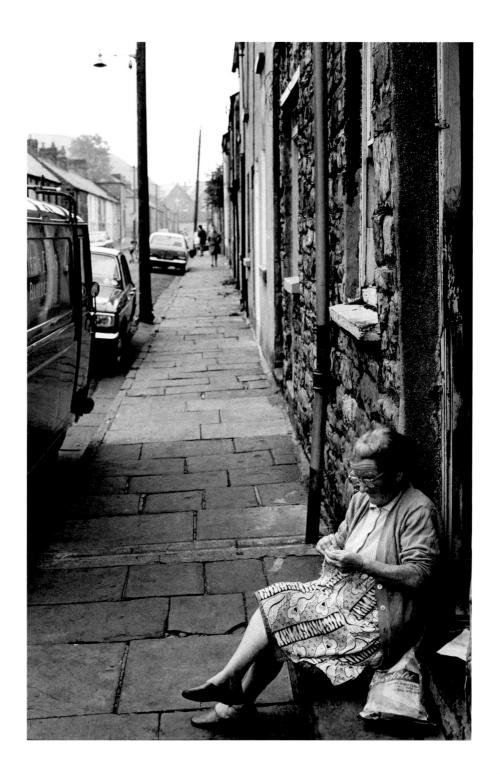

Woman knitting on the doorstep, Georgetown. Women could often be seen sitting on their doorsteps like this. Georgetown was built to house workers from the Cyfarthfa Ironworks and was a close-knit community. Shortly after this photo was taken the entire area was bulldozed for redevelopment.

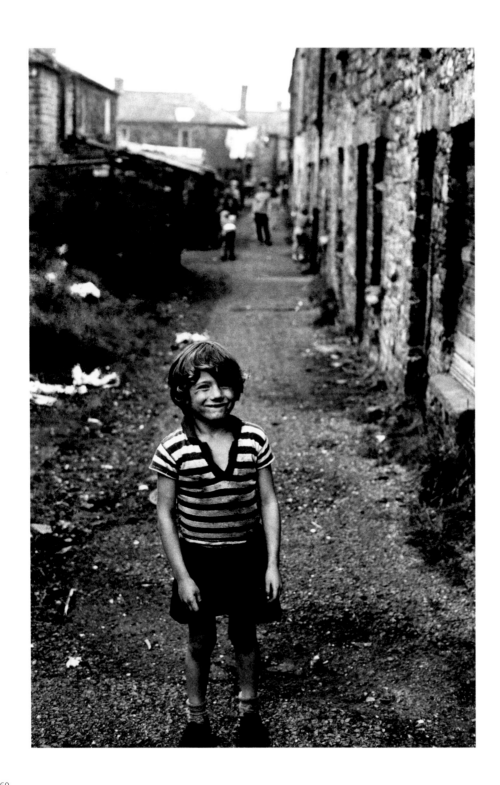

Child playing in the street, Georgetown.

Playing football outside the Salvation Army building in Dowlais.

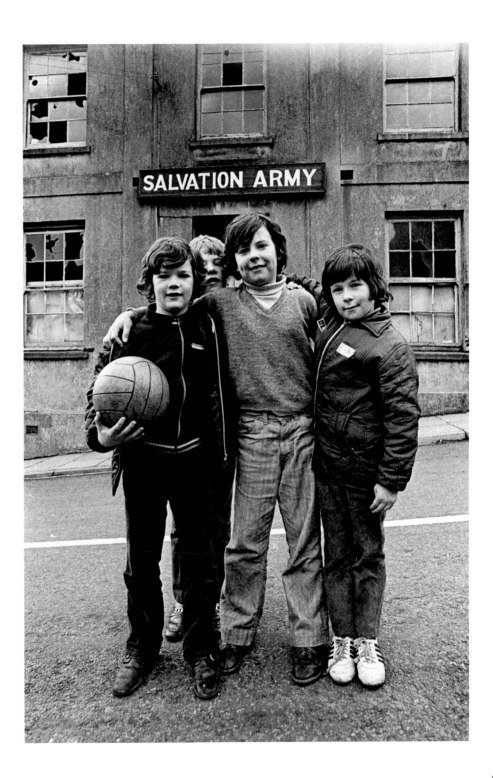

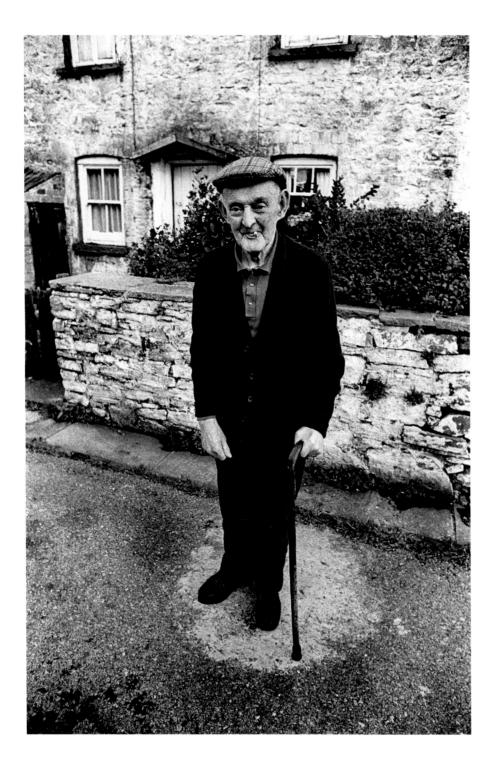

The last man to live in the Triangle, which consisted of three rows of houses built in an unusual triangular formation for the workers of the Plymouth Ironworks. The houses were bulldozed and cleared in the 1970s to make way for an industrial development.

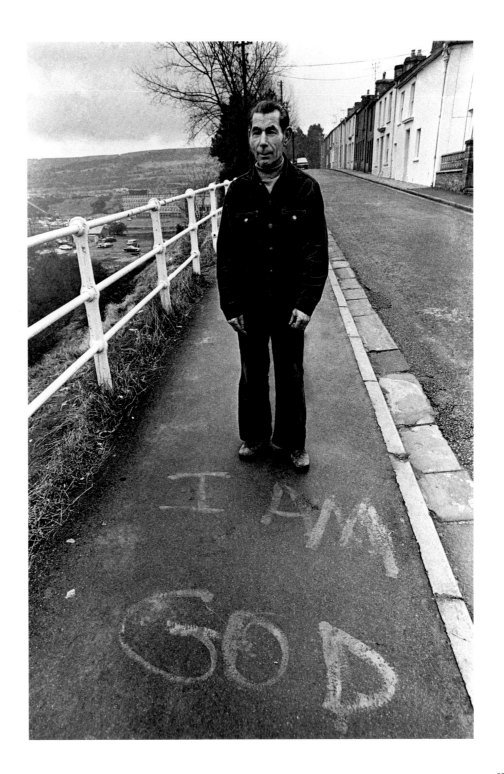

God in denim on the British Tip in Merthyr. "I'm God," he shouted at me as I was passing.

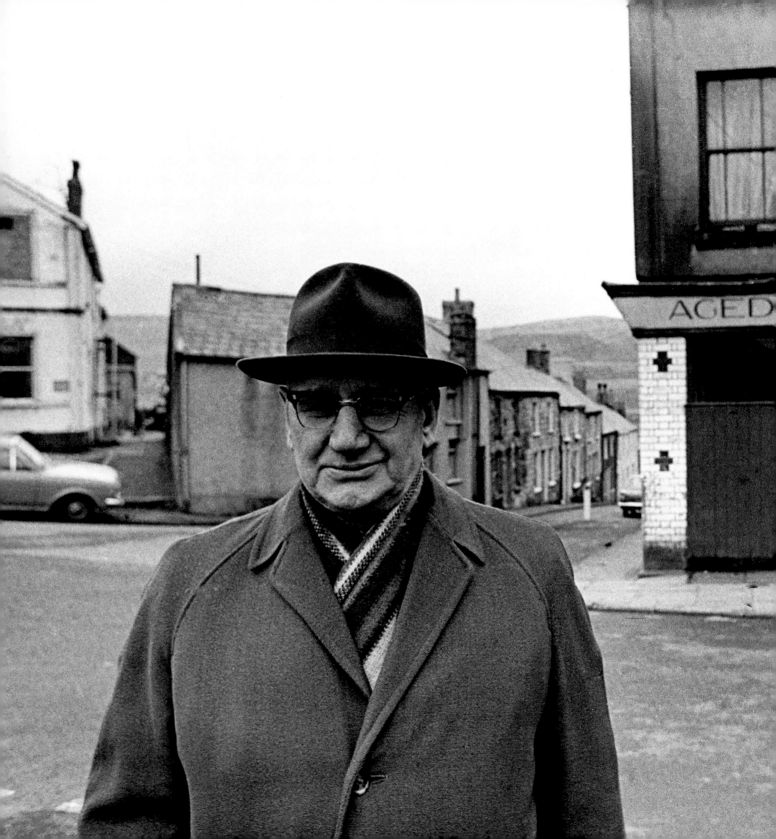

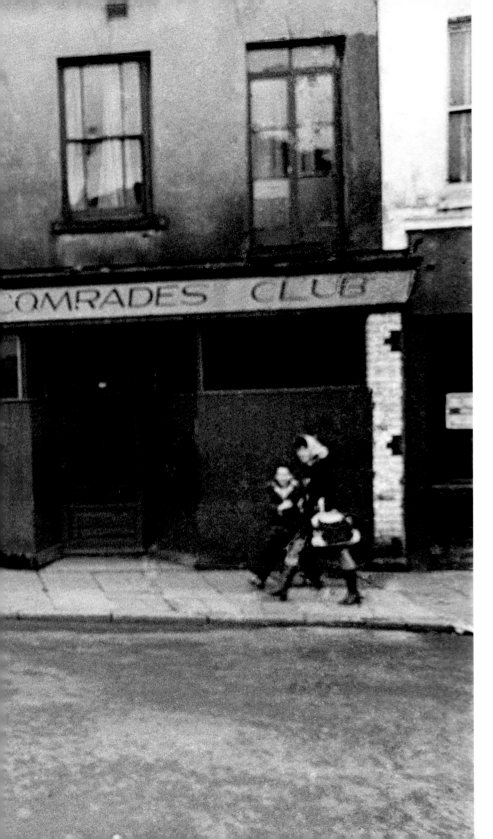

Pensioner outside the Old Comrades' Club in Dowlais.

Mrs Powell. She lived alone in a small house in Winchfawr at the top of Heolgerrig.

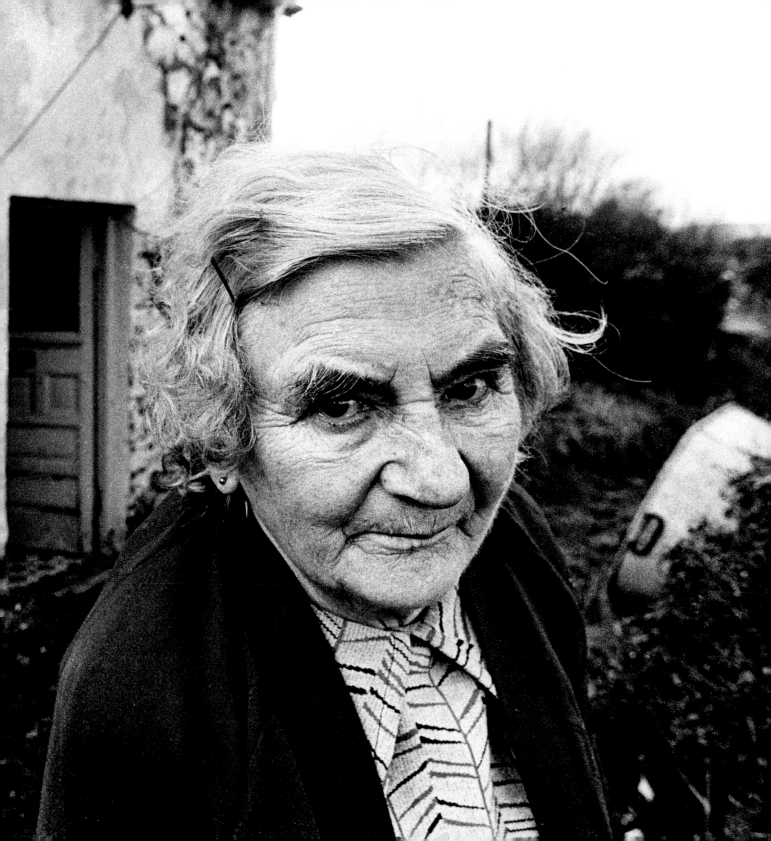

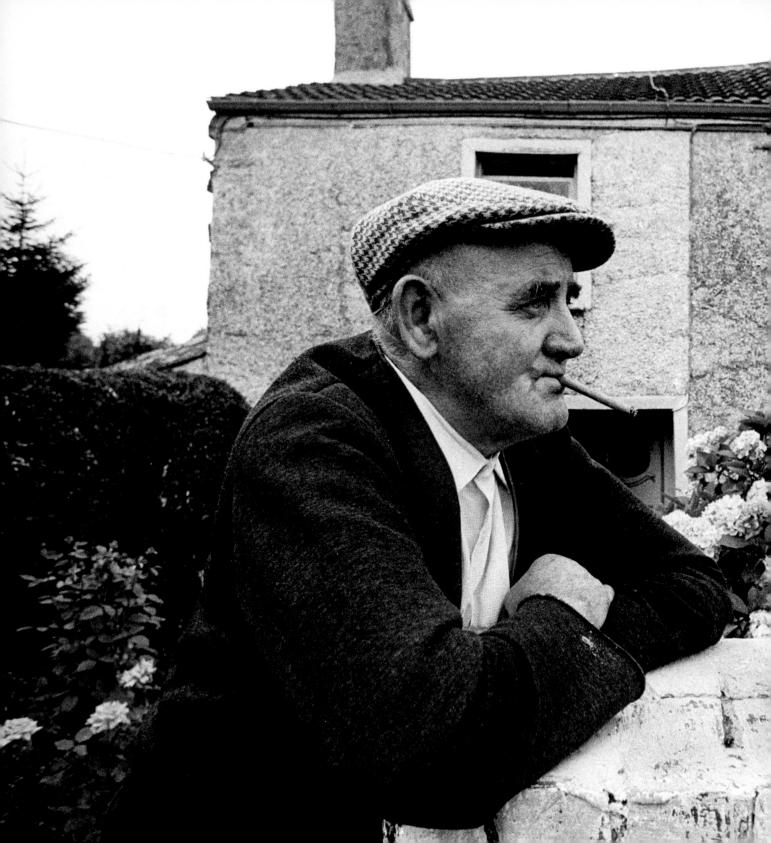

Shenko Bugail – Shenkin the shepherd. Another old collier, he only spoke in riddles and his conversation consisted entirely of an endless string of wise, old sayings spoken in either English or Welsh depending on the company. He was a lovely old soul.

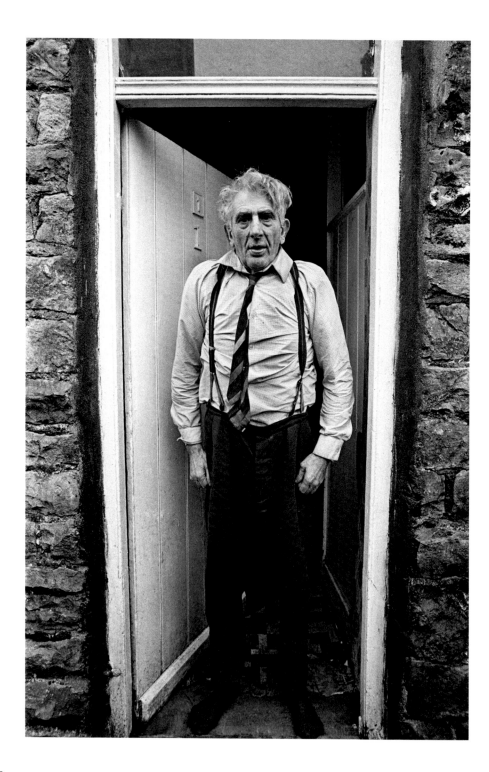

Shenkin Haines was my grand-father's half-brother. They looked like identical twins. Shenkin had just got out of bed when this photograph was taken.

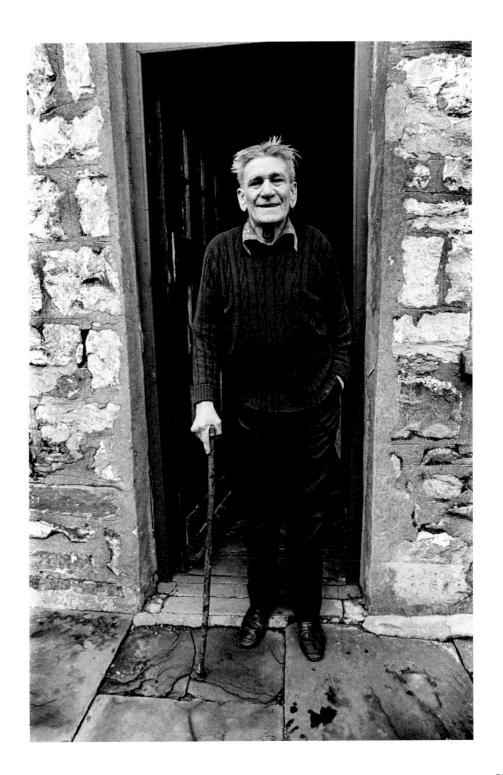

Dai Wills was a collier who had kept greyhounds when he was younger. He loved rabbiting and foxhunting.

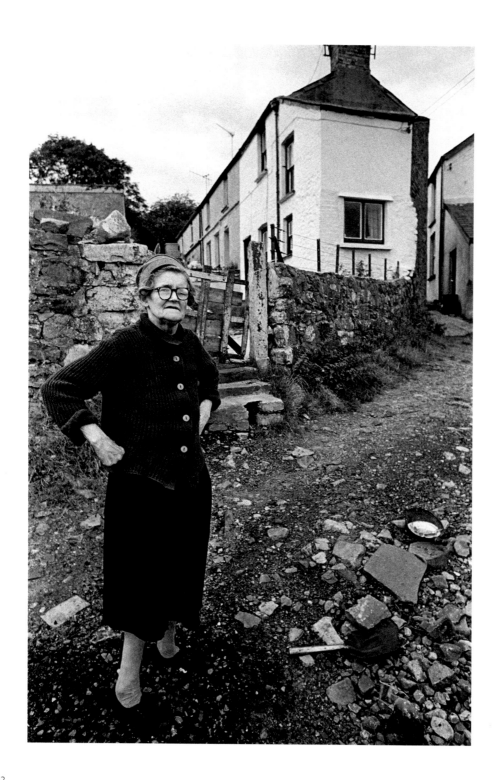

Old woman shovelling stones after a flood. There had been a tremendous downpour which had washed away some stones. This woman was trying to move them with a small shovel.

Maggie Perrin and her son Mansell. Maggie had her own stone on the edge of a coal tip. On sunny days she would always be found sitting on this stone greeting passers-by. Her son Mansell had been born with health problems.

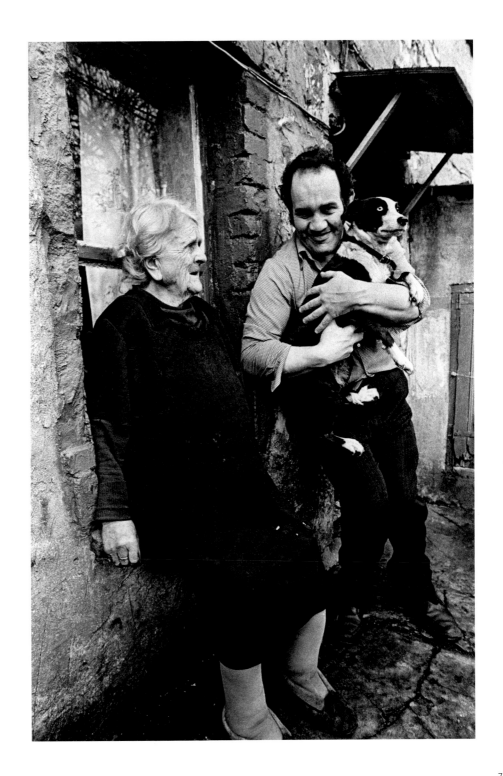

Lewis Evans and his wife Martha. Lewis was a collier and a music teacher. Outside his front door was a brass plaque that read 'Lewis Evans Piano Teacher'. He once wrote a song which was published. Martha was preparing lunch.

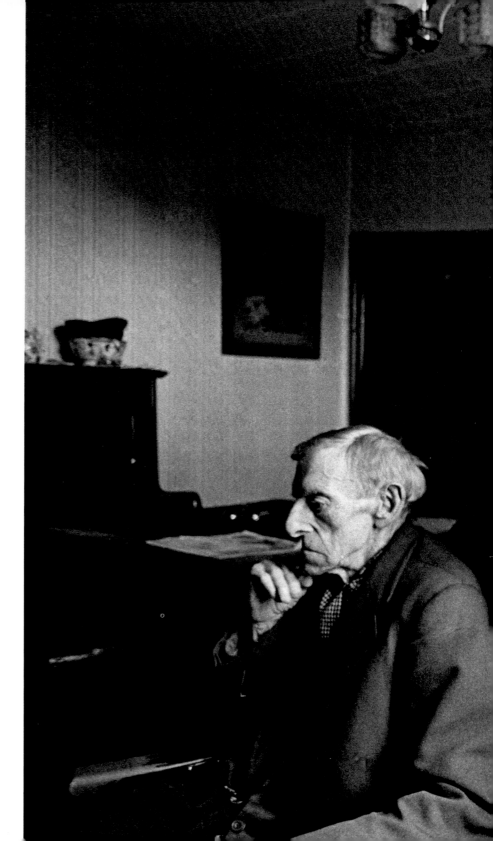

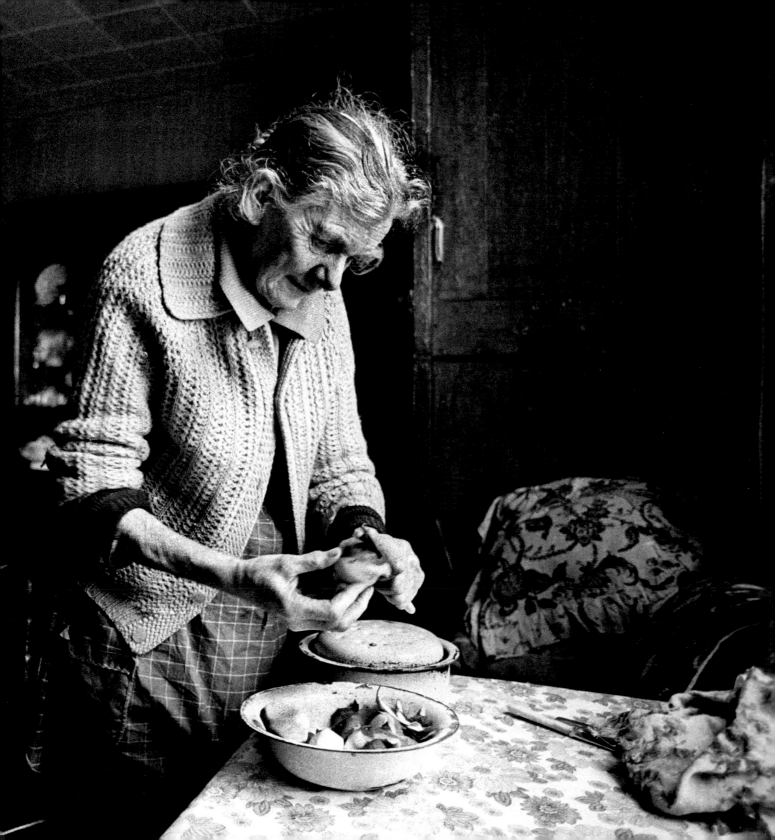

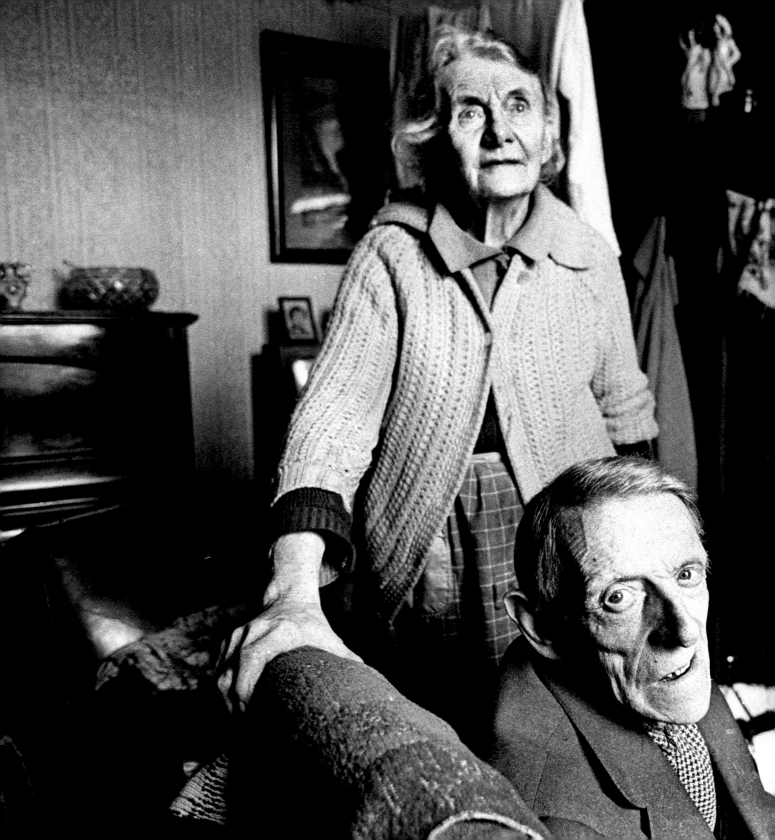

Lewis Evans and his wife Martha in front of their wonderful range fireplace. When they passed away the house was completely renovated and the fireplace removed.

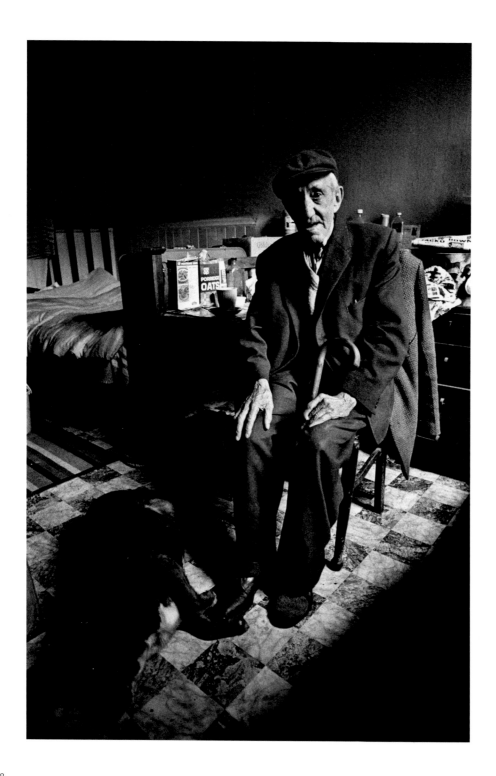

A resident at the Castle Hotel. This man shared a room at the lodging house with Bill Baldy. It was a place for people who'd fallen on hard times.

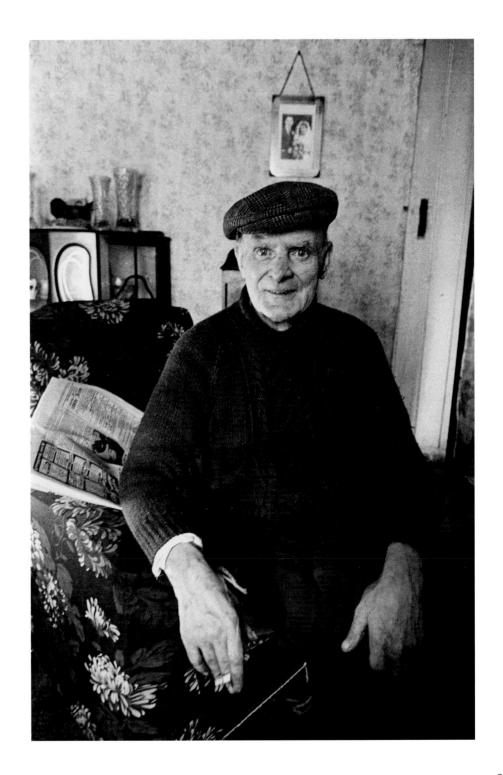

Rowley Coed was a real character. He lost part of a finger in a mining accident. "Rowley don't care a shit about nobody," he used to say.

Ngai Yee Liu in the Castle Street Chinese takeaway. Ngai was nineteen and had moved with his family from Hong Kong five years before to open the town's first Chinese takeaway. What struck him more than anything was the amount of fighting in the streets. His family later moved on to Vancouver, but he stayed. On this occasion I had popped in on the way home from visiting my grandfather in hospital.

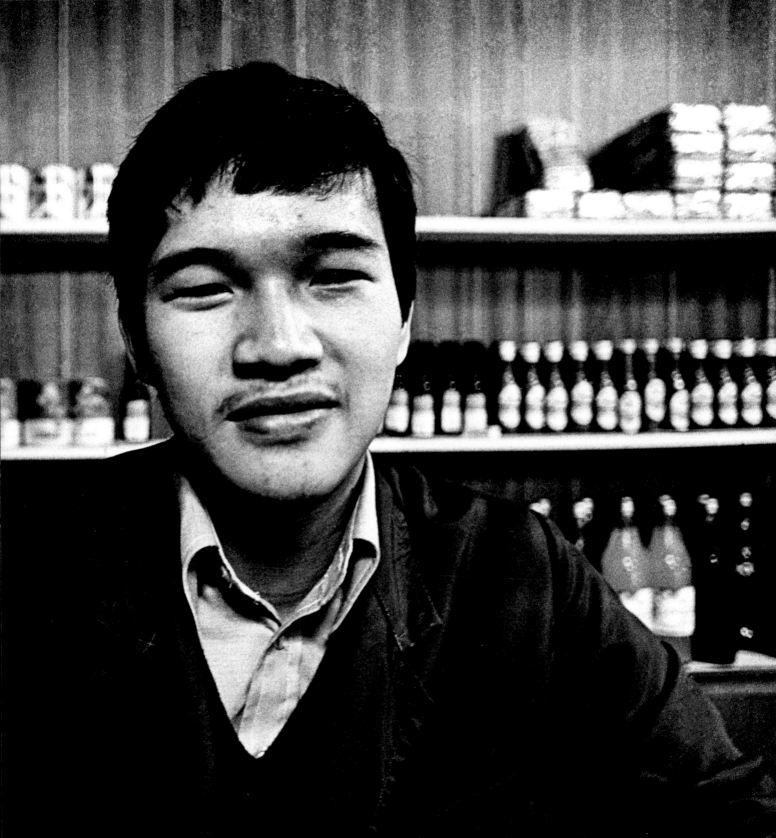

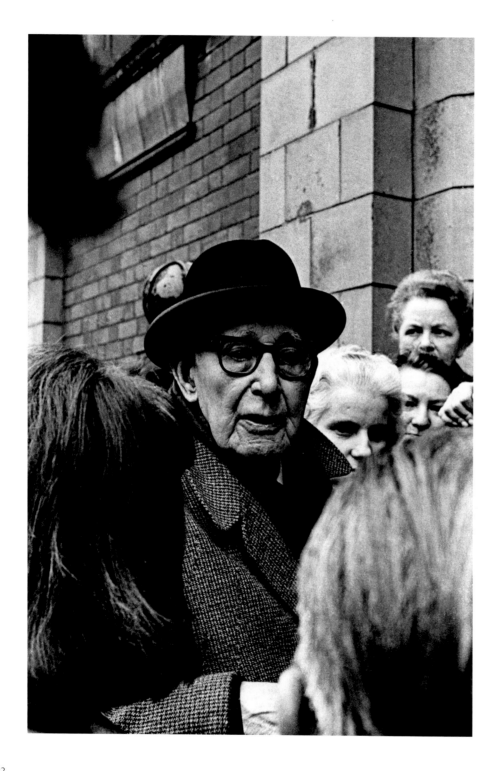

Stephen Owen 'Siegfried' Davies – known as S.O. He began work as a coal miner at the age of 12, studying for a degree in his spare time. He eventually became Vice President of the Miner's Federation of Great Britain and was MP for Merthyr Tydfil for almost forty years, from 1934-72. When this photo was taken he was 84 and had just been deselected by the local Constituency Labour Party who thought him too old to stand for re-election. Undeterred, he decided to stand as an Independent and I photographed him as he was being mobbed by his supporters outside the town hall. He won the election.

The Brigadier was a character of complex identity who frequented The Lamb. A brigadier in the Free Wales Army, he did more drinking than fighting. During the time of the investiture of the Prince of Wales, Special Branch police used to follow him. He would bring a pair of wellies to the pub and when they followed him home he would lead them along the longest route he could think of – through streams and muddy fields. He was once arrested with six others in Mid Wales when he was wearing a Sam Brown belt with a holster. The police officer ordered him to disarm. He told the officer that he would have to disarm him. Duly the officer removed a Tesco tin opener from the holster.

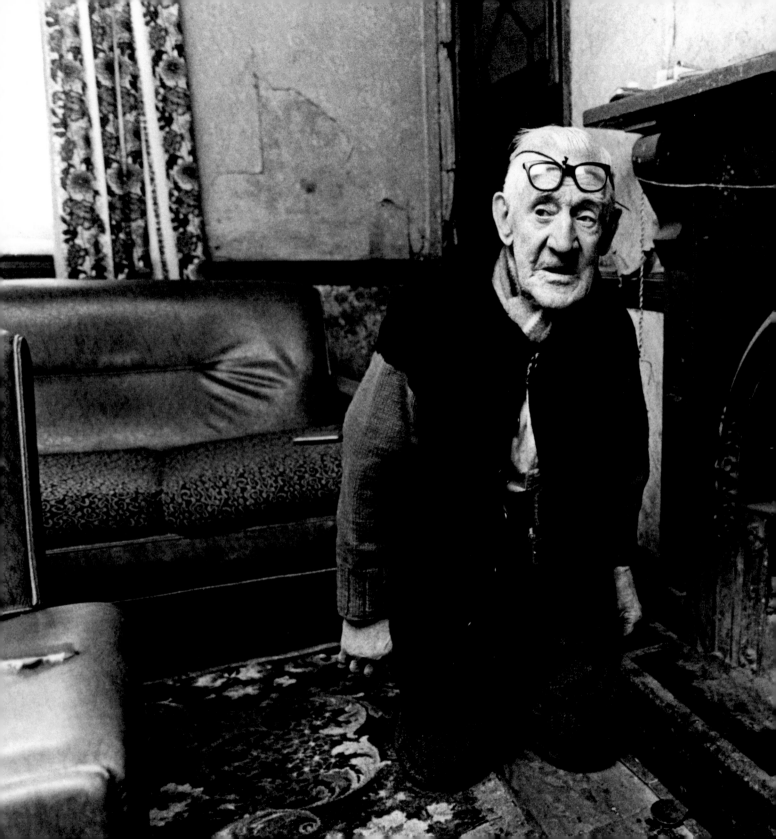

I have no idea who this man was.
He invited me into his home to take
his portrait.

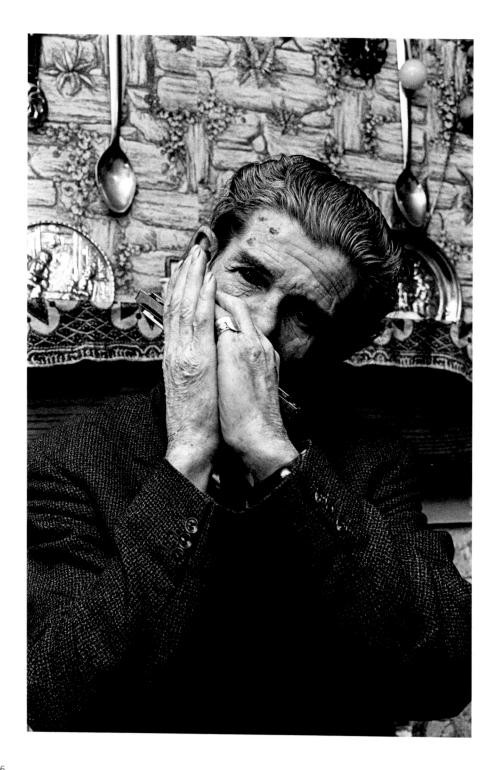

Old Mister Jones playing the harmonica. He was quite accomplished although he rarely played outside his home, unlike his brother, Moses the Mouthorgan, who was always to be found playing in the pubs.

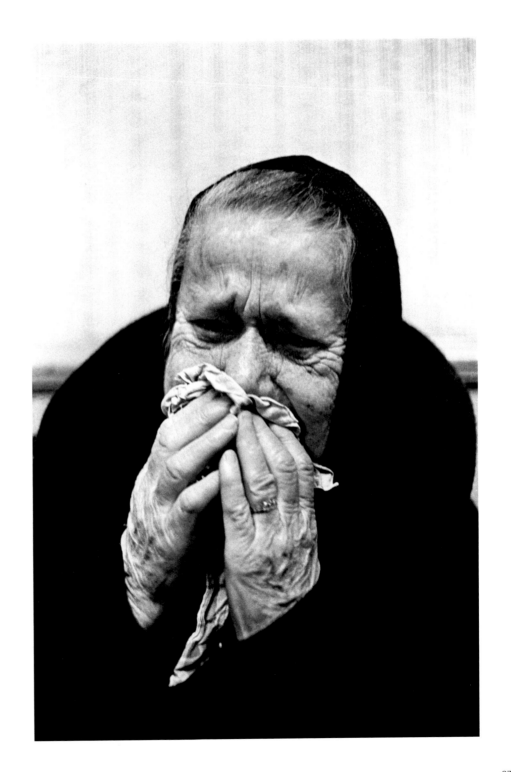

Old woman crying, dressed in black.
I think there had been bereavement
in her family.

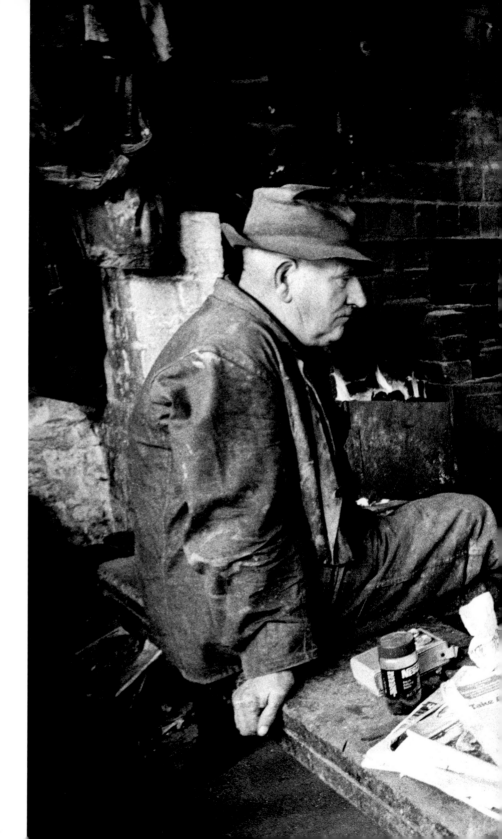

Tommy Gravedigger and his team, taking a break in the gravediggers' hut at Cefn Cemetery. Tommy once had a wager with a workmate that whoever died first would return and give a sign if there was an afterlife. The workmate died and Tommy was convinced that he had come back, and had made a tremendous noise on the roof of the hut. After that Tommy was always wary of being in the hut on his own.

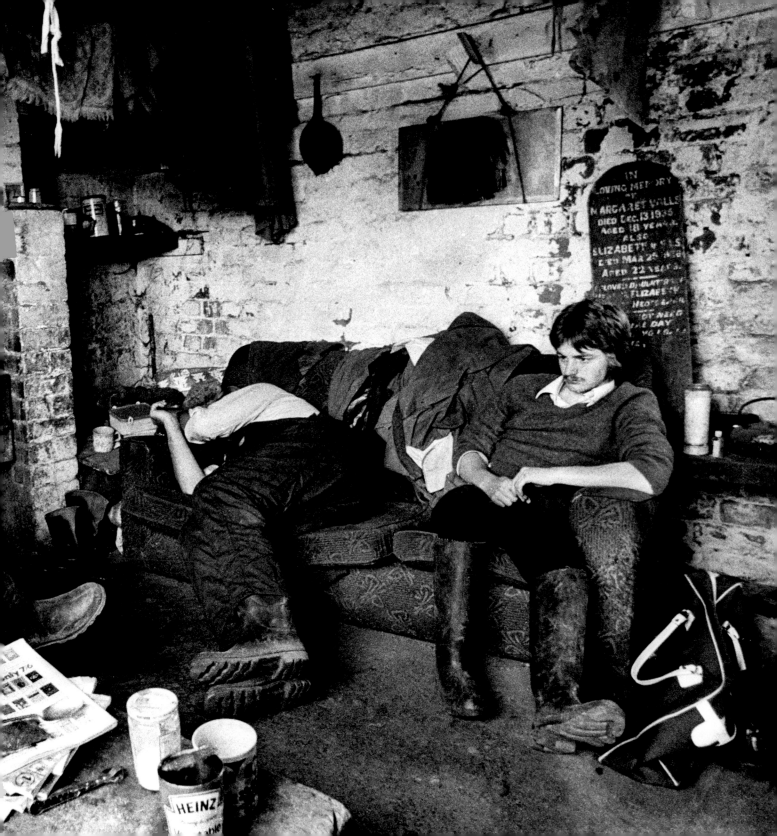

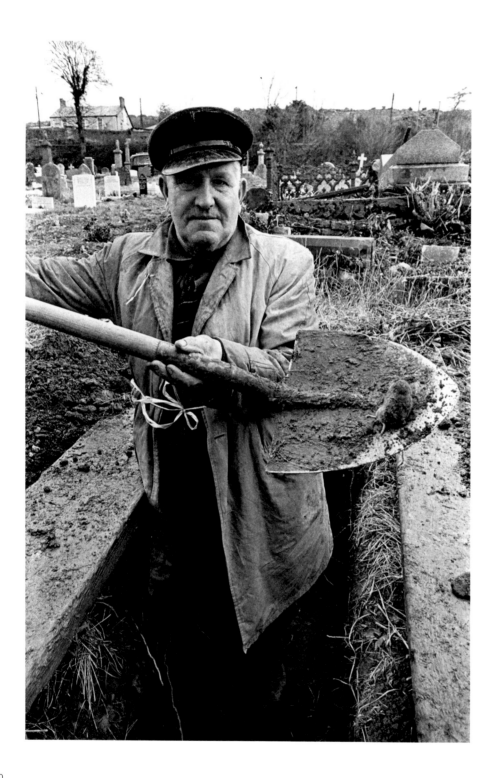

Tommy Gravedigger removing a dead mouse from a grave. Mice often fall into open graves at night and are invariably found dead in the morning. Tommy had buried over 7,000 people at Cefn Cemetery. He was the caretaker of the dead from Heolgerrig. He knew where every family was buried. His wife had died twenty years earlier after choking on an apple. He gave her a lovely spot, he said, sheltered by the trees. He also said that occasionally when he walked around the cemetery his attention would inexplicably be drawn to a gravestone, and that this was a sign that there was going to be a death in that family. Usually there was.

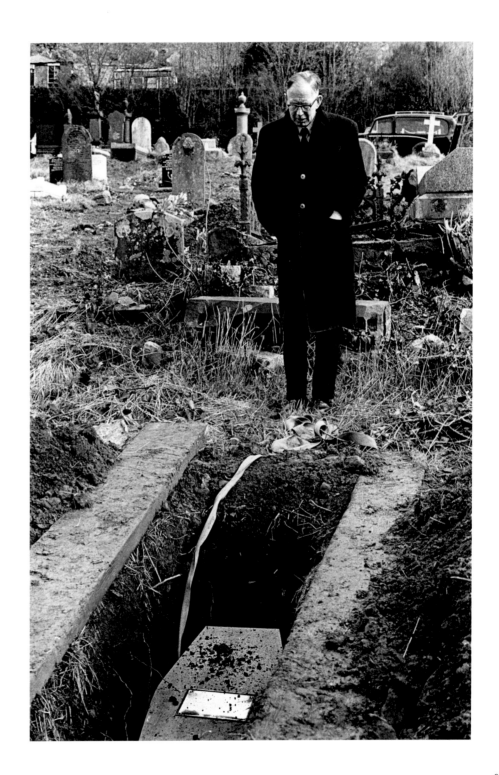

A pauper's burial at Cefn cemetery. The deceased had no friends or relatives and so the funeral was paid for by the council. Only the undertaker and a vicar were present. Griffiths the undertaker stands over the grave.

Griffiths the undertaker and the Reverend Kenneth Hayes at the pauper's funeral. Reverend Hayes lost a child when the coal tip engulfed the school at Aberfan in 1966, killing 116 pupils and 5 teachers.

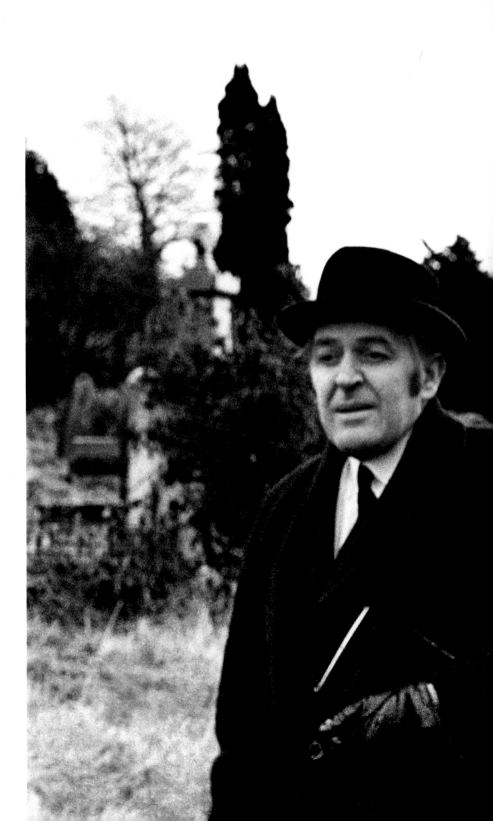

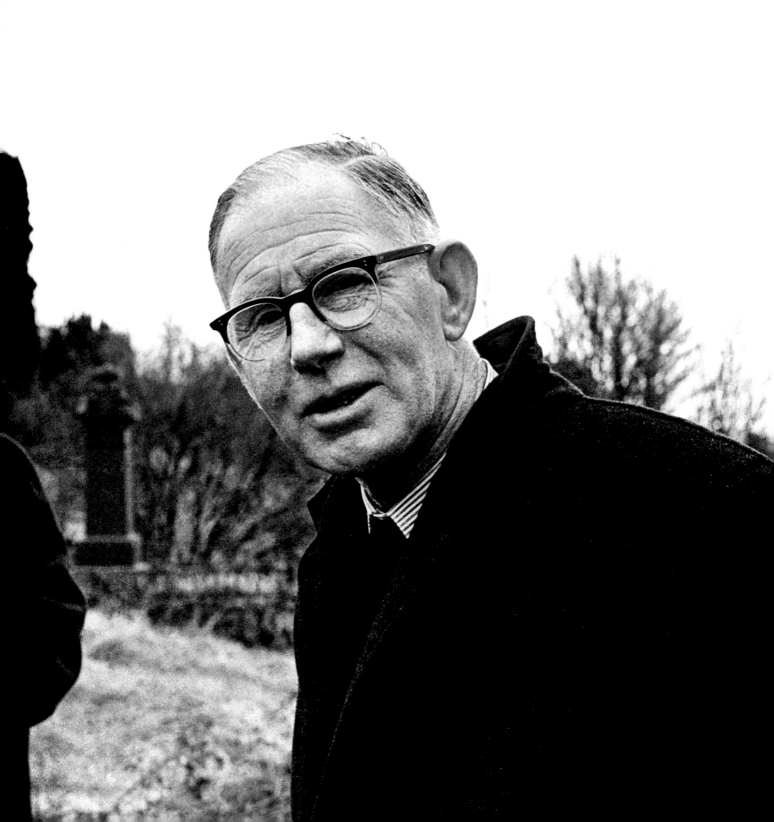

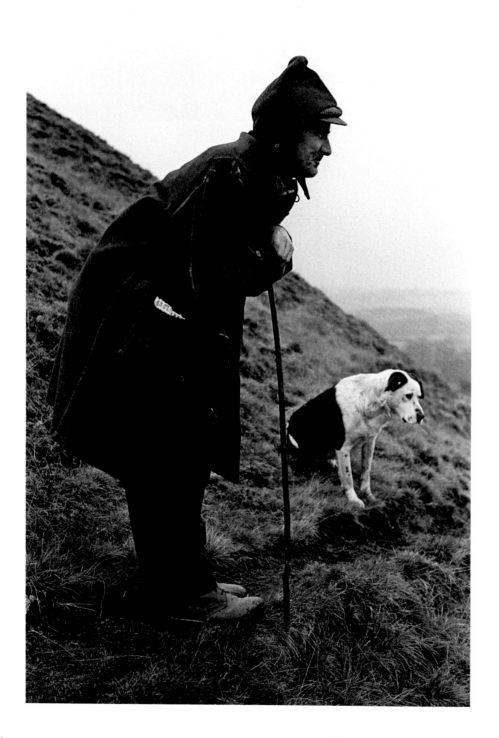

Dai Passmore and his dog. Dai could often be found wandering the slag tips above Heolgerrig. He had a complex of sheds at the base of the tips where he kept ferrets and pigs. He used to be seen driving a horse and cart around town. He liked stout.

This photograph was taken on January 4th 1972. It started to snow, a very light snow, just as I took the photograph. I remember it so well because it was at this precise moment that my Nan passed away.

Nan – Ann Haines, my grandmother.
The maker of the finest pancakes
and Welsh cakes in the whole,
wide world. Photographed in her
doorway, number 65 Heolgerrig,
in the summer of 1971, her last
summer. She was seventy-four.

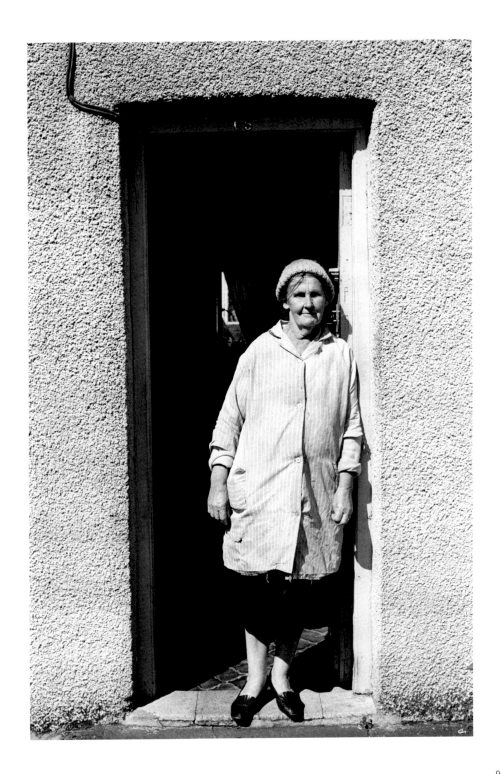

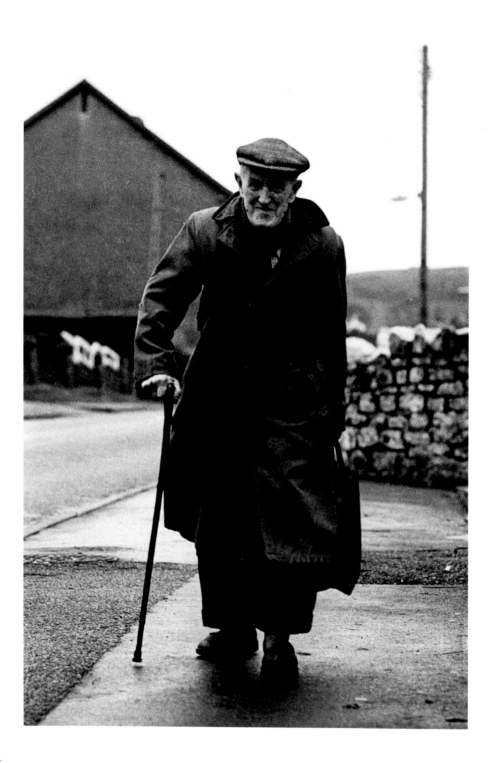

Dai the back, was a little, old collier who lived in No.4 Back of Six Bells – the house in which he was born. These were small cottages converted many years earlier from Heolgerrig's first Independent Chapel. Dai was one of ten children. He rarely went out and never married. His brother Brinley was my head teacher at Heolgerrig Junior School, and was an extremely talented musician who accompanied a choir that sang in London in front of King George V and Queen Mary.